THE
PHILADELPHIA
FLYERS

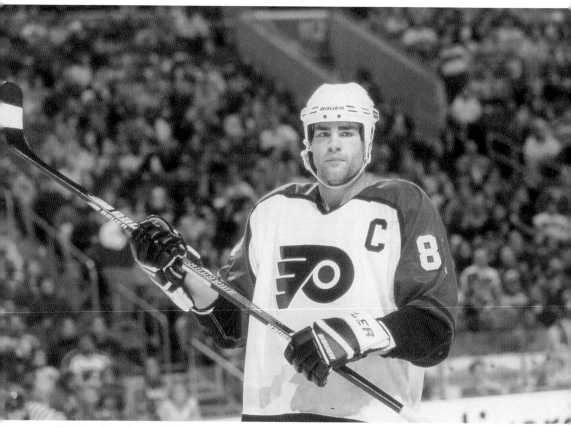

Eric Lindros changed the face of hockey in the 1990s with his brute force and size coupled with his tremendous play-making ability. The National Hockey League (NHL) had rarely seen a six-foot-four, 240-pound player who could barrel through the defense and wrist a shot over a prone goaltender. He had tremendous size and innate skill. He was one of the most dominant players in the NHL in the 1990s. (Courtesy of the Philadelphia Flyers.)

FRONT COVER: Here, Bobby Clarke, who led the Philadelphia Flyers to two Stanley Cup championships, epitomizes what being a Flyer means. He combined top talent with grit and did not understand the word "quit." (Photograph by Joe del Tufo.)

COVER BACKGROUND: The NHL selected the Philadelphia Flyers to play in the third Winter Classic against one of their hated rivals from the 1970s, the Boston Bruins. (Photograph by Joe del Tufo.)

BACK COVER: Former Philadelphia Flyers defenseman Braydon Coburn and then New York Rangers forward Brian Boyle square off before a full house. (Photograph by Mike del Tufo.)

THE
PHILADELPHIA
FLYERS

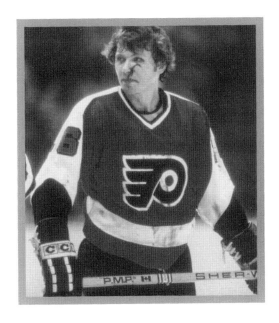

Russ Cohen, Mike del Tufo, and Joe del Tufo
Introduction by Bruce "Scoop" Cooper

ARCADIA
PUBLISHING

Published by Arcadia Publishing
Charleston, South Carolina

Printed in the United States of America

Library of Congress Control Number: 2015953498

For all general information, please contact Arcadia Publishing:
Telephone 843-853-2070
Fax 843-853-0044
E-mail sales@arcadiapublishing.com
For customer service and orders:
Toll-Free 1-888-313-2665

Visit us on the Internet at www.arcadiapublishing.com

We would like to dedicate this book to Flyers fans
around the globe who love the game of hockey.

CONTENTS

ACKNOWLEDGMENTS

We'd like to thank the folks at Arcadia Publishing and title manager Jeff Ruetsche for making this project possible. We'd also like to thank our friends and family for their unwavering support. A special thanks goes to Bruce "Scoop" Cooper for his amazing contribution. Thanks is owed to the Flyers organization for opening up its photograph archives to us. A special thanks is given to Brian McBride, the Comcast Spectator archives manager, for fulfilling every request and to Zack Hill for getting us in the building. Photographs in this book were taken by Joe del Tufo, Mike del Tufo, Russ Cohen, Drew King, Amy Irvin, and Fran Rubert. Archival photographs were contributed by the Philadelphia Flyers.

FOREWORD

For the almost half century since 1967, the simple six-letter word "Flyers" has meant only one thing to the legion of diehard sports fans in Philadelphia: hard-fought, tough-as-nails hockey. This volume presents a historical retrospective in words and pictures of how their beloved Flyers made that city one of the leading hockey towns in the world and what the team, its players, and the people of Philadelphia have all meant to each other over the past nearly half century.

The NHL Philadelphia Flyers, however, were hardly the first professional hockey team to ever set up shop in our nation's birthplace looking to capture the hearts of the passionate sports fans of William Penn's "greene countrie towne." That quest began 40 years before the Flyers ever played a game when, in the fall of 1927, the upstart Philadelphia Arrows became the sixth member of the then year-old Canadian-American (Can-Am) Hockey League, playing at the dank 5,500-seat arena at Forty-Sixth and Market Streets in West Philadelphia.

Over the next four decades, the Arrows were followed to the arena ice by no fewer than seven other professional clubs, playing in five different leagues and each seeking to establish the game as a major sports fixture in the city. Only one, the 1935–1936 Philadelphia Ramblers, brought Philadelphia any kind of hockey title in the Can-Am circuit's Frank Fontaine Cup. The legacy of all the others, however, proved to be much less grand with two setting still-standing records for futility in their loops for fewest wins in a season. The 1930–1931 NHL Philadelphia Quakers won just four times in their one and only campaign, and 16 years later, the American Hockey League (AHL) Philadelphia Rockets notched but five victories in 1946–1947. And as bad as those two teams were, yet another one-season wonder, the Tri-State Hockey League Philadelphia Comets, outdid even those clubs by never winning a game at all in their only season of play at the Philadelphia Arena in 1932–1933.

Those four decades of professional hockey mediocrity began to come to an end, however, with the advent of the NHL Philadelphia Flyers in October 1967 that, in less than seven years, completely reversed the city's lackluster hockey record; in 1974, the orange and black became the first NHL expansion team to win the Stanley Cup and repeated the feat a year later with a second consecutive NHL playoff title. Ironically, the success of Philadelphia's then newest major league team also served as the catalyst that finally inspired each of the city's three other long-suffering major league sports franchises—the Phillies, Eagles, and 76ers—to finally achieve excellence too.

On the muggy Sunday afternoon of May 19, 1974, just six years and eight months after playing their first game, the "Broad Street Bullies" completed Philadelphia's sports metamorphosis with a home ice 1-0 shutout of Bobby Orr, Phil Esposito, Ken Hodge, and the rest of the then powerhouse Boston Bruins. And with that stunning victory, the Flyers completed their playoff final series upset of the Bruins, four games to two, to become the first expansion team to capture North America's oldest trophy continuously competed for by professional athletes—the Stanley Cup.

Two days later, more than a million Philadelphians lined Broad Street to celebrate in the biggest such gathering in the city's over-300-year history.

The Flyers continued their reign as one of the world's top-performing sports franchises for almost a decade and a half following that first cup win. After repeating as Stanley Cup champions in 1975, they reached the finals four more times in 1976, 1980, 1985, and 1987 during the 13-year stretch from 1974 to 1987 and returned there twice more in 1997 and 2010. And in regular season play over that same period, the club finished in first place in its division an incredible nine times, second three more times, and as low as third only twice.

The Flyers most incredible feat of all during that stretch, however, was the streak in 1979–1980. After splitting the first two games of the campaign, the club established an unprecedented and unlikely ever-to-be-matched all-time major league professional sports standard by not losing again for almost three months, going 35 games (25-0-10) without a loss.

The Flyers' successes clearly seemed to inspire the city's three other major league tenants of Philadelphia's massive sports complex at the south end of Broad Street. In the decade after the Flyers brought the Stanley Cup to town for the first time in 1974, each of those three other teams finally awoke from their prolonged doldrums and each also won a title. In 1980, the Phillies won their first ever World Series in almost a century of play, the Eagles took the National Football League's National Football Conference (NFC) title a couple of months later, and the 76ers won their only National Basketball Association (NBA) crown in 1983.

In addition to the great success the Flyers had as a team in those glory years, many individual honors were also bestowed upon its members both on and off the ice. In 1984, two-time Vezina Trophy– and Conn Smythe Trophy–winning netminder Bernie Parent became the first player ever elected to the Hockey Hall of Fame based on a career spent almost entirely with an expansion club. Parent was followed into the hall in 1987 by three-time league MVP and all-time Flyer scoring champion (1,210 points) Bob Clarke. The club's all-time leading goal-scorer at 420, Bill Barber joined his two Stanley Cup teammates in the players' section of the hall in 1990.

The front office is represented by Flyers' chairman Ed Snider, who was elected to the Hall of Fame as a "Builder" in 1988 and was followed four years later in 1992 by the man who literally built the Flyers' greatest teams on the ice, general manager Keith Allen. Allen, who was hired a year before the team played its first game to be the club's first coach, was later the Flyers' general manager for 13 of its most successful seasons. Fred Shero, the Flyers' bench boss in their 1974 and 1975 Stanley Cup winning runs, joined them in the hall posthumously in 2013 and defenseman Chris Pronger was elected in 2015.

In addition to Parent, goalies Pelle Lindbergh (1984–1985) and current Flyers' general manager Ron Hextall (1986–1987) also captured the Vezina Trophy as the league's top netminder. In 1976, high-scoring winger Reggie Leach won the Smythe Trophy as the Stanley Cup MVP despite his club's loss in the final to the Montreal Canadiens, and Hextall did the same as a rookie goalie in 1987 when the Flyers lost to the Edmonton Oilers in seven games.

Three of the Flyers' first six head coaches—Fred Shero in 1973–1974, Pat Quinn in 1979–1980, and Mike Keenan in 1984–1985—won the Jack Adams Award as NHL's coach of the year. And Shero, Allen, Snider, and Clarke—who retired as a player in 1984 to become just the fourth general manager in Flyer history—have each also won the league's prestigious Lester Patrick Trophy for "outstanding service to hockey in the United States."

One of the most difficult things to do by far in sports after achieving excellence is to sustain it year after year. However, through hard work on the ice and astute management off of it, the Flyers have been able to maintain their status as one of the premier teams in sports almost without interruption since their first game in 1967. Even though the club had a five-year stretch in the late 1980s when it missed the playoffs and has not won another Stanley Cup since 1975, over its history, it trails only the Montreal Canadiens (.589) among the NHL's 30 currently active and dozen defunct teams in career winning percentage (.578) and is also 21 percentage points ahead of third place Boston (.557).

With the likes of many other former and current Flyer players such as Claude Giroux, Brian Propp, Rick MacLeish, Eric Lindros, Tim Kerr, Dave Poulin, Simon Gagne, Mark Howe, John LeClair, Eric Desjardins, Wayne Stephenson, Mark Recchi, Rod Brind'Amour, Rick Tocchet, Chico Resch, Danny Briere, Jake Voracek, Steve Mason, Pete Peeters, Kimmo Timonen, Ken Linseman, Brad McCrimmon, Brad Marsh, Kevin Dineen, Brian Boucher, and hundreds more who have donned the club's orange and black since 1967, you will see in the following pages why Flyer hockey played at the south end of Broad Street in the now departed Spectrum and their current home, the Wells Fargo Center, has been a major draw for Philadelphia's sports fans for almost half a century now.

—Bruce "Scoop" Cooper

Philadelphia-based hockey historian Bruce "Scoop" Cooper has been covering the Flyers and other professional hockey teams in Philadelphia as a writer, historian, and broadcaster since the late 1960s. (Photograph by Joe del Tufo.)

1

THE LINDROS ERA

Eric Lindros suited up in the orange and black for the first time in October 1992. Lindros quickly established himself as a dominating force and turn the Flyers into a Stanley Cup contender by his third season with the team. He was named captain of the team in September 1994. Lindros led the team to the Eastern Conference Finals in 1995 and 2000 and to the Stanley Cup Final in 1997.

In terms of individual achievements, Lindros claimed the Lester B. Pearson Trophy in 1995 and the Hart Memorial Trophy as the league's most valuable player that same season. He was also named to the NHL All-Star team on six occasions (1994, 1996, 1997, 1998, 1999, and 2000) as well as the Flyers' MVP on four occasions (1994, 1995, 1996, and 1999).

Lindros's tenure with the team was very memorable and exciting. These Flyers' squads always seemed to be right on the cusp of winning a championship.

Prominent teammates of Lindros during this era include the following: John LeClair, Eric Desjardins, Rod Brind'Amour, Mark Recchi, Keith Primeau, Simon Gagne, Ron Hextall, Dale Hawerchuk, and Mikael Renberg.

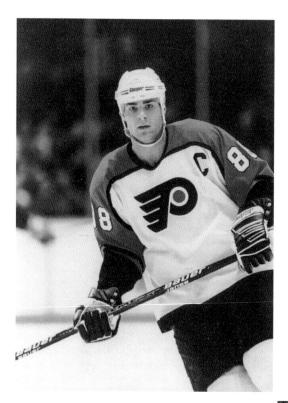

Few hockey players have such a spotlight on them as Eric Lindros did before his NHL career began. He was the No. 1 overall pick in the 1991 NHL Entry Draft but refused to play for the team that selected him. This opened the door for a huge trade that saw the Flyers part with numerous roster players, draft picks, and $15 million to bring Lindros to Philly. (Courtesy of the Philadelphia Flyers.)

Eric Lindros did a lot of celebrating while he was with the Flyers. He centered the well-known "Legion of Doom" with wingers John LeClair and Mikael Renberg and compiled 290 goals and 659 points in 486 games. His most famous goal was in Game 4 of the 1997 Eastern Conference Final when he scored with 6.8 seconds left to put the Flyers one game away from the Stanley Cup Final. (Courtesy of the Philadelphia Flyers.)

THE LINDROS ERA

John LeClair was the perfect complement to center Eric Lindros. The imposing size of each of these forwards was quite a difficult task for opposing defenses to face. LeClair would record three straight 50-goal seasons from 1995–1996 to 1997–1998 while he was on the same line as Lindros. The duo led the Flyers to one Stanley Cup Final and three Eastern Conference Final appearances. (Courtesy of the Philadelphia Flyers.)

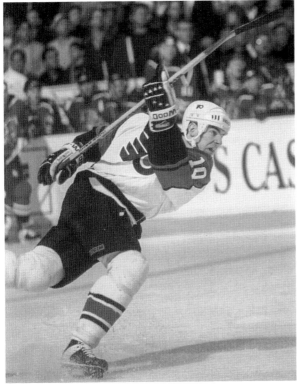

John LeClair was acquired in 1995 in what is considered one of the best trades the Flyers have ever made. LeClair had a tremendous, blistering slap shot that was one of the best in the league in the 1990s. With skilled playmakers like Eric Lindros and Eric Desjardins, LeClair often found the puck in his wheelhouse and blasted away. He scored 333 goals in 649 games with the Flyers, an average of 42 goals per season. (Courtesy of the Philadelphia Flyers.)

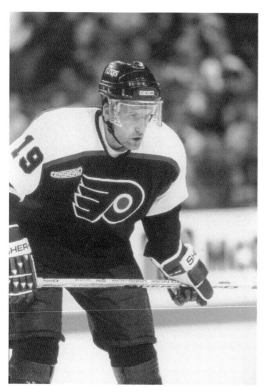

Forward Mikael Renberg made an immediate impact as a Flyer, scoring 139 points in his first 130 games with the team from 1993 to 1995. The big Swede was a nice fit on a line with burly Eric Lindros and John LeClair, and the trio, known as the Legion of Doom, terrorized the NHL for several seasons. They led the team to the 1997 Stanley Cup Final. (Courtesy of the Philadelphia Flyers.)

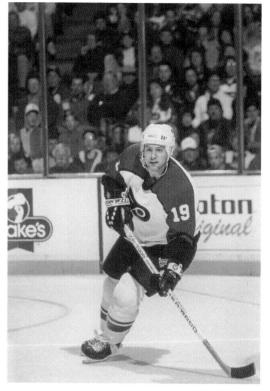

Mikael Renberg was the third member of the Legion of Doom line, with Eric Lindros and John LeClair. The Flyers drafted him 40th overall in the 1990 NHL Entry Draft. He went on to set the club record for most points in a season scored by a rookie with 82 points on 38 goals and 44 assists. Renberg compiled 296 points in 366 games for the Flyers. (Courtesy of the Philadelphia Flyers.)

The Flyers drafted defenseman Dmitri Tertyshny 132nd overall in the 1995 NHL Draft. He joined the team in 1998 as a 22-year old and played in 62 games, scoring 2 goals and 10 points. He had some ups and downs, but overall, the Flyers liked what they saw. Tragically, Tertyshny only played that season for the team, as he was killed in a freak boating accident in July 1999. (Courtesy of the Philadelphia Flyers.)

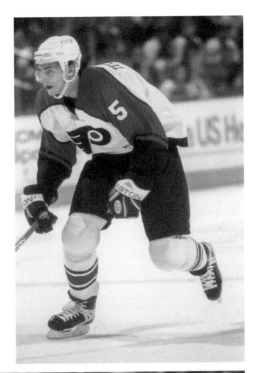

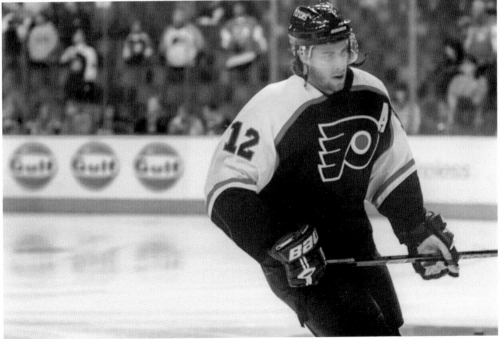

Simon Gagne had quite a career with the Flyers that spanned an impressive collection of players. Early on, he played with Eric Lindros, John LeClair, Keith Primeau, and Jeremy Roenick. Then, he was teammates with Peter Forsberg, Danny Briere, Mike Richards, Jeff Carter, and Claude Giroux. He saw the team completely turn over around him. (Photograph by Joe del Tufo.)

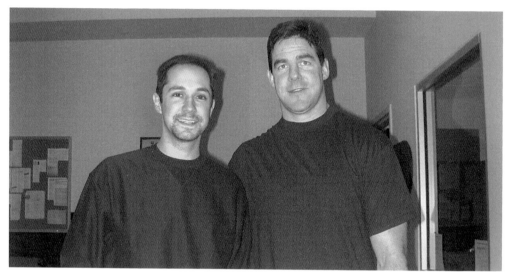

On February 9, 1995, John LeClair was acquired along with Eric Desjardins and Gilbert Dionne from the Montreal Canadiens in exchange for Mark Recchi and a draft pick. It is considered one of the best trades the Flyers have ever made. LeClair had three consecutive 50-goal seasons for the team from the 1995–1996 season to the 1997–1998 season. Here, LeClair (right) poses with Flyers fan Barry Crell after practice. (Photograph by Joe del Tufo.)

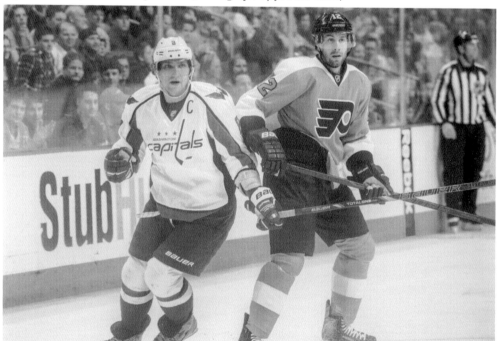

After a lengthy tenure with the Flyers, Simon Gagne was traded to the Tampa Bay Lightning in 2010. He went on to win a Stanley Cup with the Los Angeles Kings in 2012 before the Kings traded him back to the Flyers. In his return game back as a Flyer, he played against Alexander Ovechkin and the Washington Capitals. (Photograph by Drew King.)

THE LINDROS ERA

FLYER LEGENDS

The Philadelphia Flyers joined the National Hockey League in 1967. They were not part of the revered Original Six. They may not have existed as long as the Montreal Canadiens or Boston Bruins, but nevertheless, the Flyers have quite an impressive roster of superstars who have laced up the skates for the team.

Goalie Bernie Parent and center Bobby Clarke stand out the most, but there are still numerous other individuals who have made a significant impact with the orange and black and in the NHL. They include Flyers owner Ed Snider, Bill Barber, Reggie Leach, Rick MacLeish, Gary Dornhoefer, Pelle Lindbergh, David Schultz, Dave Poulin, Rick Tocchet, Brian Propp, Ron Hextall, Joe Watson, Jim Watson, Mark Howe, Eric Lindros, John LeClair, and Eric Desjardins.

This section highlights the players and individuals who have had outstanding careers with the Flyers. Many of them are in the Flyers Hall of Fame and/or the Hockey Hall of Fame.

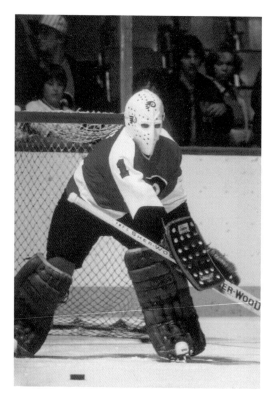

Flyers legendary goalie Bernie Parent amassed 271 wins and 55 shutouts in the NHL. He was an original Flyer, as they selected him in the 1967 NHL Expansion Draft from the Boston Bruins. He had split the 1966–1967 with the Bruins and their minor league club, so the Bruins opted to not protect him for the expansion draft. Ironically, it was the Bruins that Parent and the Flyers defeated in the 1974 Stanley Cup Final. Parent was inducted into the Hockey Hall of Fame in 1984. (Courtesy of the Philadelphia Flyers.)

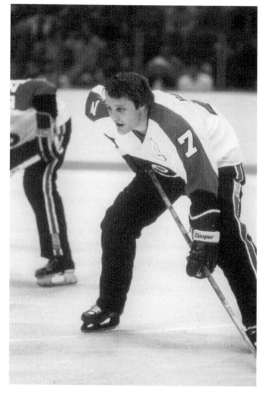

Bill Barber, who was inducted into the Hockey Hall of Fame in 1990, readies for action during the short stretch when the team experimented with playing in long pants. The Flyers were one of only two NHL teams to experiment with "Cooperalls" during two seasons in the early 1980s. (Courtesy of the Philadelphia Flyers.)

FLYER LEGENDS

Winger Bill Barber has an extensive list of accomplishments as a Flyer. He is the Flyers' career leading goal scorer with 420 regular season goals. He was also a member of both Stanley Cup winning squads, served a stint as the team's captain, and was the team's head coach. While Barber was the team's head coach in 2001, he also won the Jack Adams Award as coach of the year. (Courtesy of the Philadelphia Flyers.)

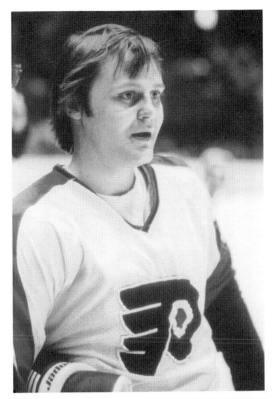

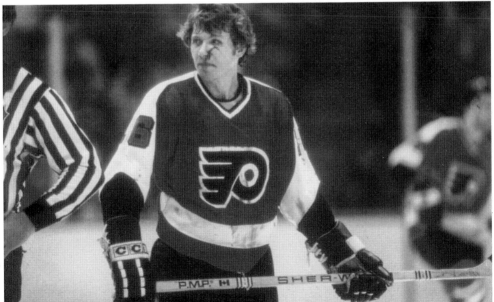

No one ever questioned Bobby Clarke's heart. He persevered through the toughest times, no matter how much of his blood ended up on his jersey. He captained the Flyers to two Stanley Cup Championships in the 1970s and leads the team in many major career categories including most points (1,210), games (1,144), and assists (852). (Courtesy of the Philadelphia Flyers.)

There was no one more responsible for the Flyers earning the nickname the "Broad Street Bullies" than Dave Schultz. He was one of the most feared fighters in the history of the NHL and still holds the NHL record for most penalty minutes in a single season. He amassed an astounding 472 penalty minutes during the 1974–1975 season. (Courtesy of the Philadelphia Flyers.)

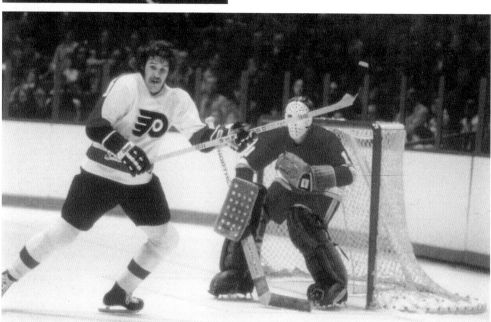

Dave Schultz, who is nicknamed the "Hammer," is rarely recognized for his skill, but he did record 20 goals for the Flyers during the 1973–1974 season. He also scored a crucial goal for the Flyers in 1974 as the team claimed its first Stanley Cup. He scored the series-clinching goal in overtime in the first round of the 1974 Stanley Cup playoffs against the Atlanta Flames. (Courtesy of the Philadelphia Flyers.)

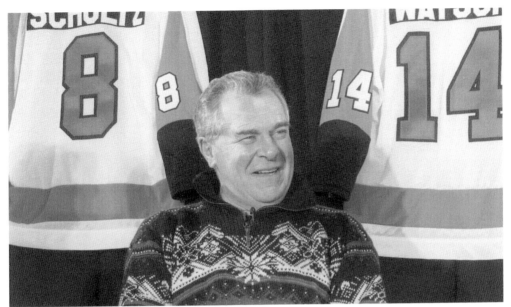

Joe Watson is half of the famous brother tandem who were both on the Philadelphia Flyers championship squads. This five-foot-ten blueliner was a memorable piece of the Broad Street Bullies. In 1966–1967, he was voted the fourth-best rookie in the National Hockey League. His teammate Bobby Orr won the Calder Memorial Trophy, and the next year, the Flyers selected Watson in the expansion draft. (Photograph by Mike del Tufo.)

Terry Crisp played for the infamous Broad Street Bullies. This NHL journeyman found a home in Philadelphia and spent the last five years of his career there. Before Bobby Orr, "Crispy," as he was known, was the first player from Parry Sound, Ontario, to ever play in the National Hockey League. (Photograph by Mike del Tufo.)

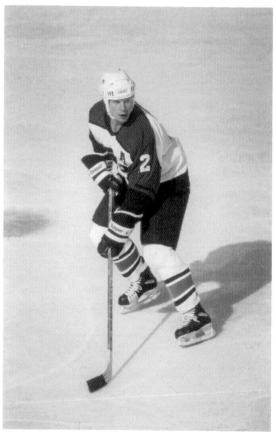

Mark Howe patrolled the Flyers' blueline for 10 seasons, from 1982 to 1992, and is generally considered the best defenseman for the franchise ever. He was a frequent finalist for the James Norris Memorial Trophy as the league's best defenseman and led the team to two berths in the Stanley Cup Final. He is also the career leader for Flyers defenseman in points (480), goals (138), and assists (342). (Courtesy of the Philadelphia Flyers.)

When he first entered the NHL, Mark Howe was initially known most for being the son of Gordie "Mr. Hockey" Howe. After being acquired by the Flyers in early 1980s, he made his mark on the league and established himself as one of the top defensemen in the NHL. He was inducted into the Hockey Hall of Fame in 2011. (Courtesy of the Philadelphia Flyers.)

Center Rick MacLeish was the first-ever Flyer to score 50 goals in a season. He scored 50 goals and added 50 assists for 100 points during the 1972–1973 season. MacLeish played 10 seasons for the franchise, scoring 328 goals, which ranks him sixth all-time for the team. He also scored 697 points, which ranks him fourth all-time for the team. (Courtesy of the Philadelphia Flyers.)

The Flyers selected Pelle Lindbergh with the 35th overall pick in the 1979 NHL Entry Draft. Following that, he impressed at the 1980 Olympics at Lake Placid as a member of Team Sweden. He was the only goaltender that Team USA did not beat on the way to the gold medal. Sweden and the USA tied 2-2. Lindberg died tragically in a car accident in 1985 while he still held the position as the Flyers' starting goalie. (Courtesy of the Philadelphia Flyers.)

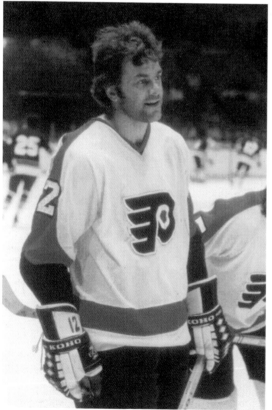

Rick MacLeish was a member of both of the Flyers' Stanley Cup Championship teams. He arguably scored the greatest goal in Flyers' history—the cup-clinching goal in Game 6 of the 1974 Stanley Cup Final against the Boston Bruins. On May 19, 1974, at the Spectrum in Philadelphia, MacLeish scored at the 14:48 mark of the first period, the only goal scored, leading to the Flyers' win 1-0 and their first Stanley Cup. (Courtesy of the Philadelphia Flyers.)

Gary Dornhoefer was an original Flyer. He was left unprotected by the Boston Bruins, and the Flyers selected him with 13th overall pick in the expansion draft. He went on to play 725 games for the team scoring 518 points, which ranks him 10th all-time. Dornhoefer was a member of both of the Flyers' Stanley Cup Championship teams. (Courtesy of the Philadelphia Flyers.)

Gary Dornhoefer scored one of the biggest goals in Flyers' history on April 10, 1973. On that date at the Spectrum in Philadelphia, he scored an overtime goal against the Minnesota North Stars to put the Flyers up three games to two in the best-of-seven series. The Flyers then went on to win Game 6 to win their first-ever playoff series. (Courtesy of the Philadelphia Flyers.)

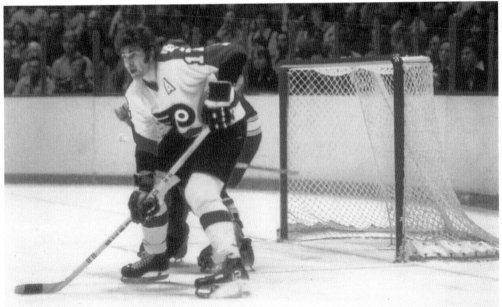

Gary Dornhoefer was named to play in the NHL All-Star Game in 1973 and 1977. He scored 202 career goals for the Flyers but was known more for his bruising style of play. An important member of the Broad Street Bullies, he recorded seven seasons with 100-plus penalty minutes and had a career total of 1,256 penalty minutes. (Courtesy of the Philadelphia Flyers.)

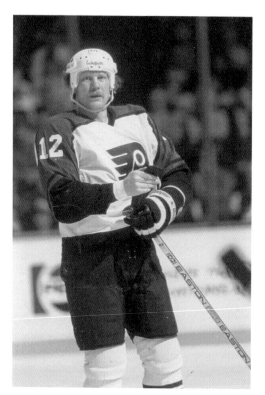

Not much was expected of Tim Kerr coming out of juniors. He went undrafted, and the Flyers signed him as a free agent in 1980. He rewarded the Flyers by recording four straight 50-plus goal seasons from 1983–1984 through 1986–1987. He still holds the Flyers' record for most 50-goal seasons. He also holds the NHL record for the most power-play goals in a season with 34 during the 1985–1986 season. (Courtesy of the Philadelphia Flyers.)

Tim Kerr was a lethal scorer in front of the net. Opposing defensemen found him very difficult to move from the crease, and once, he corralled the puck in the slot, it frequently ended up in the net. In a playoff game in 1985, he set an amazing NHL single-game record by scoring four goals in a span of 8:16 in a 6-5 win over the New York Rangers. (Courtesy of the Philadelphia Flyers.)

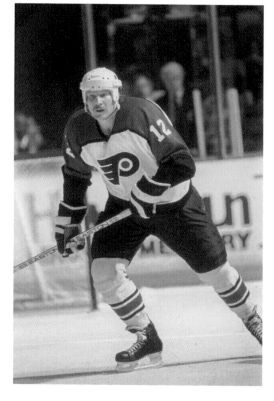

Ed Snider is the founder of the Philadelphia Flyers. It was his dream in the 1960s to have an NHL hockey club in Philadelphia. When the league decided to double the number of teams from 6 to 12 for the 1967–1968 season, Snider acted quickly. Quite the accomplished businessman, he was able to secure funding for a new arena, which was instrumental in the NHL granting him the franchise. (Photograph by Joe del Tufo.)

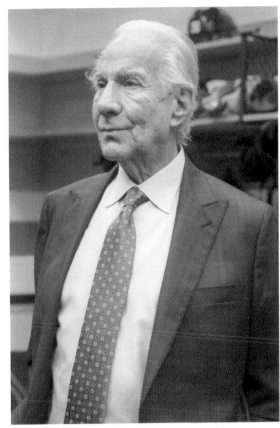

Superstar Peter Forsberg played less than two seasons for the Flyers, but he made a sizable impact, as he scored 115 points in just 100 games with the team. He dazzled the fans and the opposition with his puck-carrying prowess, but unfortunately, lower-body injuries repeatedly kept him out of the lineup. He did serve a short stint as captain of the Flyers in 2006–2007. (Photograph by Joe del Tufo.)

THE PHILADELPHIA FLYERS 27

Dave Schultz was a nasty combatant on the ice. He ruled the rink and reveled in intimidating the opposition. Off the ice is a whole different story. Schultz enjoys interacting with the fans and relaying old war stories. In this picture, he is about to add his autograph to a jersey already inundated with the autographs of other distinguished Flyer legends. (Photograph by Mike del Tufo.)

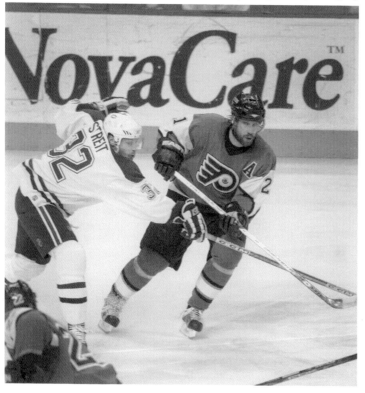

Center Peter Forsberg was renowned for his skills with the puck. He was a superb playmaker who was extremely difficult to knock off of the puck. Here, he enters the zone with the puck and makes a play against the Montreal Canadiens with future Flyers defenseman Mark Streit looking to thwart him. (Photograph by Drew King.)

3

BULLIES

No other NHL team evokes such images of big, burly hockey players intimidating the opposition as the Philadelphia Flyers do. Many feel the Flyers brawled their way to the top to win two consecutive Stanley Cup Championships. They gained the nickname the Broad Street Bullies in the 1970s and not only lived up to the name then, but also in all the years since.

Flyers hockey is a unique blend of skill and physicality. The Flyers enjoy winning with the gloves dropped almost as much as they do on the scoreboard. A Flyer pummeling an opponent typically causes quite a roar from the crowd as loud as any goal. Nothing seems to charge up a lagging Flyers squad or a sleepy crowd so much as a Flyers' enforcer engaging his opponent along the boards.

Some of their more bruising players throughout the years include David Schultz, Bob Kelly, Andre Dupont, Dave Brown, Craig Berube, Dan Kordic, Donald Brashear, Dan Carcillo, Zac Rinaldo, Jody Shelley, and Wayne Simmonds.

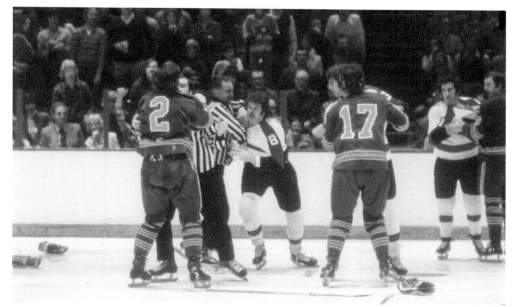

Very few players wanted to confront Dave Schultz without a referee or linesman between them. He was a rugged enforcer who backed down from no one. In the picture, he looks to battle a member of the Buffalo Sabres against the wishes of the officials. Schultz recorded an impressive 2,294 career penalty minutes in 535 NHL games. (Courtesy of the Philadelphia Flyers.)

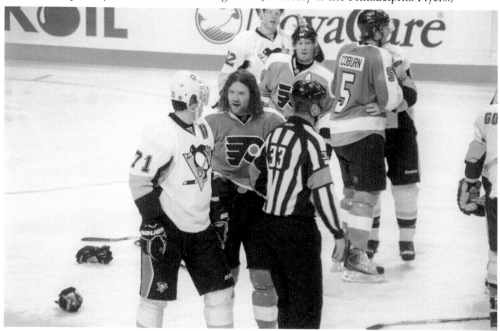

Scott Hartnell was ever the agitator when he played for the Flyers. He was confrontational and never backed down from the opposition. Some of the fiercest games the Flyers have played in recent years have been against the Pittsburgh Penguins. Here, Hartnell antagonizes Penguins forward Evgeni Malkin at the end of a huge melee. (Photograph by Joe del Tufo.)

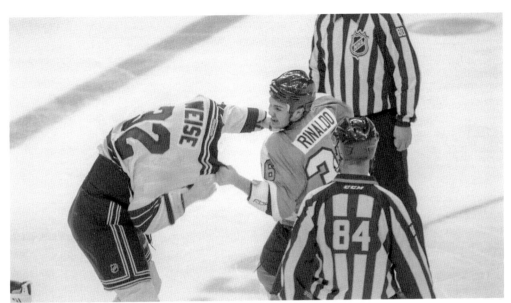

Ready to strike at a moment's notice, Philadelphia Flyers pugilist Zac Rinaldo tuned up a New York Rangers rookie Dale Weise back in the 2010–2011 season. There is never a shortage of passion and fisticuffs in this heated rivalry, and Rinaldo went with the veteran move by pulling the player's sweater over his head to put him at a big disadvantage in this situation. The refs eventually stepped in. (Photograph by Joe del Tufo.)

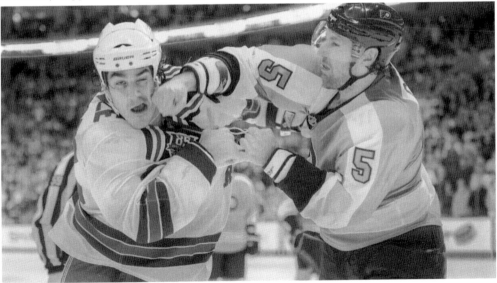

In the world of hockey, there are some strange fights that take place. One such tilt occurred between Philadelphia Flyers defenseman Braydon Coburn and then New York Rangers forward Brian Boyle. Coburn (six foot five and 220 pounds) versus Boyle (six foot seven and 244 pound) would seem to be a mismatch for the Flyers rearguard. However, Coburn landed a nice roundhouse right punch right to the glass jaw of his opponent. This shot captures what happens when one's face comes into contact with a five-finger sandwich. (Photograph by Joe del Tufo.)

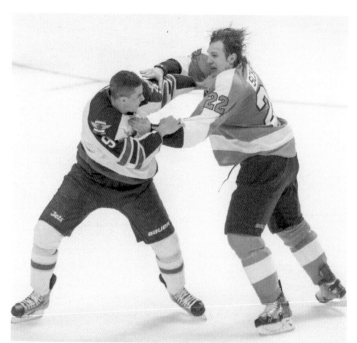

Defenseman Luke Schenn grappled with scrappy winger Evander Kane of the Winnipeg Jets in this game in 2013. Schenn, who was the fifth overall draft pick in the 2008 NHL Entry Draft, was acquired for his grit and toughness, as well as strong defensive play, in a trade the previous summer. He acquainted himself well in this tussle, and the Flyers went on to capture a 5-3 victory. (Photograph by Joe del Tufo.)

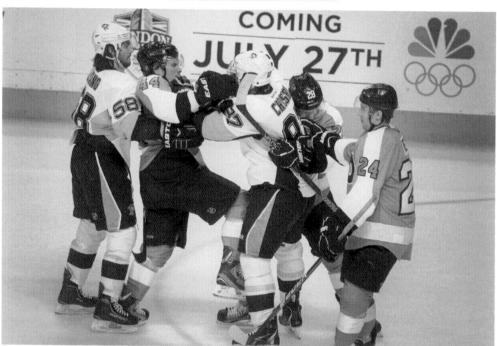

Tensions often run high when the Pittsburgh Penguins visit Philadelphia. In this picture, Flyers assistant captain Kimmo Timonen and Pens captain Sidney Crosby are locked up with various members of the two teams trying to separate them. This intrastate rivalry is usually intense and explosive, leading to exciting games with an extensive amount of penalty minutes doled out by the referees. (Photograph by Joe del Tufo.)

Donald Brashear was one of the more intimidating enforcers who has played for the Flyers since the 1980s. Brashear was a big, brawny winger who was quite adept with his fists and very tough. Plus, he was a southpaw, which kept many of the league's other tough guys off balance. In this picture, Brashear displays the effects of a rough battle after one of his outings with a fellow enforcer. (Photograph by Mike del Tufo.)

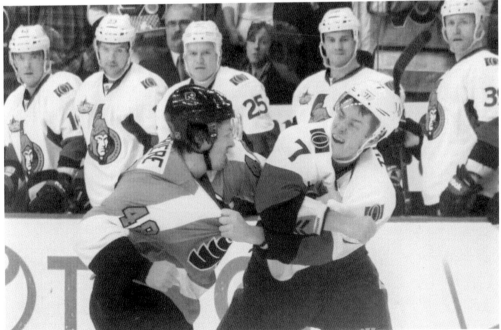

During his stint as a Flyer from 2007 to 2013, Danny Briere was primarily known for his goal-scoring prowess. He had two 25-plus-goal seasons with the team and 7 total in his career. The diminutive forward was not known for dropping the gloves. However, on this rare occasion in 2012, he fought forward Kyle Turris of the Ottawa Senators. (Photograph by Drew King.)

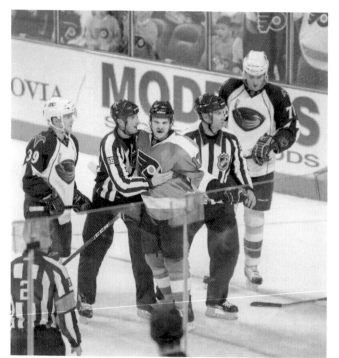

During his tenure as a Flyer, forward Dan Carcillo epitomized the team's Broad Street Bullies nickname. He played a rough game full of intensity with an eye toward dropping the gloves with anyone looking to join him in battle. Here, in a game against the Atlanta Thrashers, he directs a mean and menacing look at the opposition. (Photograph by Joe del Tufo.)

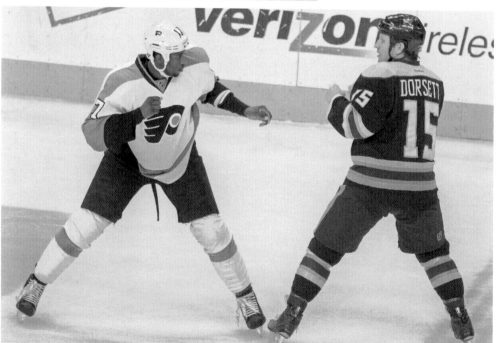

Forward Wayne Simmonds is a talented goal scorer but not one to shy away from a skirmish, as physicality is a big part of his game. Simmonds has had a number of Gordie Howe hat tricks (goal, assist, and fighting major) in his career. In this picture, he prepares to square off with Derek Dorsett of the Columbus Blue Jackets. (Photograph by Drew King.)

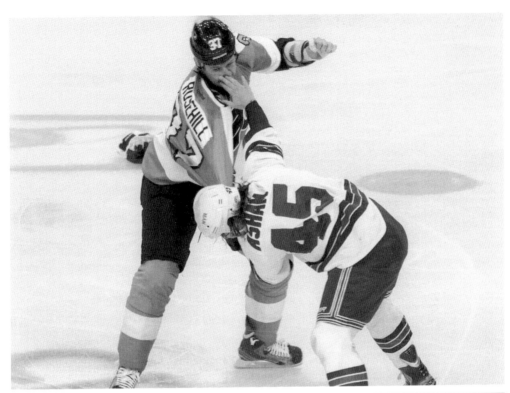

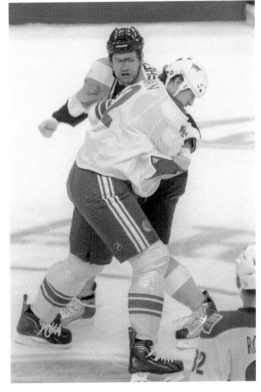

Tough guy Jay Rosehill played 45 games for the Flyers from 2013 to 2014 after being acquired from the Anaheim Ducks. He recorded three goals and 134 penalty minutes. In this picture, he fights Aaron Asham of the New York Rangers. He has Asham, a former Flyer and enforcer, at a decided disadvantage. (Photograph by Drew King.)

Jody Shelley arrived in Philadelphia in 2010 with already an impressive reputation as a skilled heavyweight fighter with stops in Columbus, San Jose, and New York. He would accumulate 191 penalty minutes in 89 games for the Flyers and finish his NHL career with 1,538 penalty minutes. In February 2011, he dropped the gloves with big Nolan Yonkman of the Phoenix Coyotes. It was a rugged, bloody battle that saw both men land major blows. (Photograph by Joe del Tufo.)

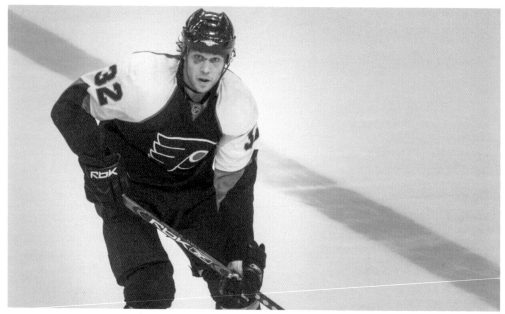

Riley Cote played for the Flyers from 2007 to 2010. He was in the lineup for 156 games, scoring one goal and earning 411 penalty minutes. Cote's role was never unclear. He was on the team for his fists, not his stick. In this picture, Cote looks like a warrior who has just been through a rough battle. (Photograph by Joe del Tufo.)

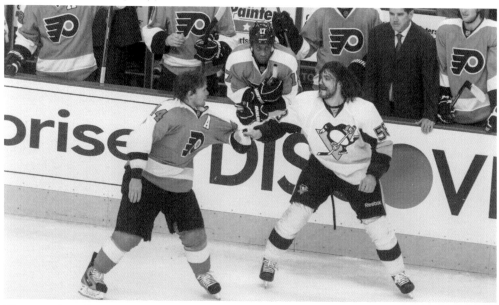

There is a lot of hatred between the Flyers and the Pittsburgh Penguins, and sometimes, it spills over to players who are not the usual suspects in terms of dropping the gloves. Flyers defenseman Kimmo Timonen and Penguins defenseman Kris Letang are highly skilled players who rarely fight, but on this occasion, the tensions on the ice compelled it. Flyers Wayne Simmonds looks on jealously, wishing he could provide a two-fist assist. (Photograph by Drew King.)

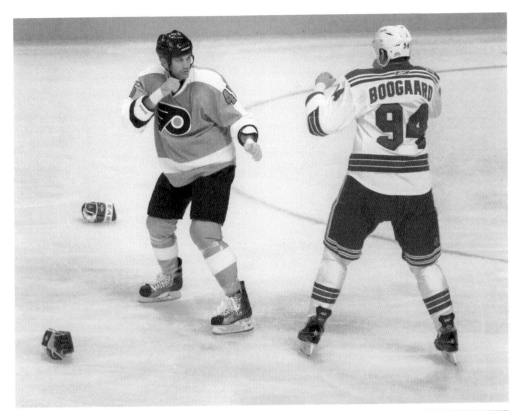

The enforcers on the Flyers and New York Rangers often get well acquainted when the two teams meet. Games between the two hated rivals often get intense and nasty, both on the ice and in the stands. Here, heavyweights Jody Shelley and Derek Boogaard prepare to square off. Shelley played two seasons for the Flyers. He compiled a total of 1,538 penalty minutes in the NHL. (Photograph by Drew King.)

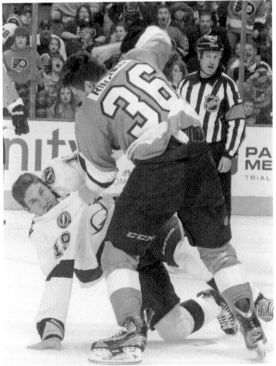

Flyers Zac Rinaldo dropped the gloves early in a contest against the Tampa Bay Lightning in February 2013. Rinaldo overwhelmed Lightning winger B.J. Crombeen in this fight, which helped give momentum to the Flyers, as they skated to a 2-1 victory. In this picture, he has Crombeen at a decided disadvantage. (Photograph by Drew King.)

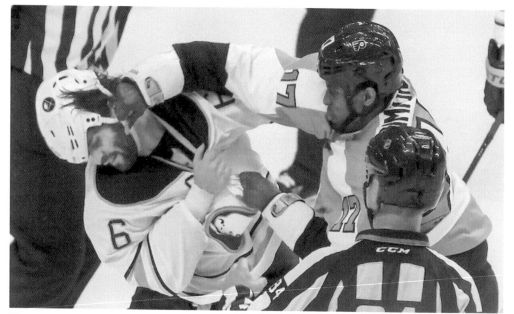

Flyers winger Wayne Simmonds is not one to shy away from a confrontation. Here, he does not hesitate at the opportunity to drop the gloves with an opposing player who weighs 25 pounds more than him in Sabres defenseman Mike Weber. In this picture, Simmonds lands a big blow to Weber's head on his way to a decisive victory in this fight. (Photograph by Drew King.)

Before the game starts, there is a pregame skate. Players warm up, take shots on their goalie, and skate around to get loose. One night, "Car Bomb" Daniel Carcillo decided to size up the opposition and another famous super pest, Sean Avery. What they talked about was anybody's best guess, but one can bet that it was not boring. (Photograph by Joe del Tufo.)

4

GOALIES

The Flyers claimed the Stanley Cup in their seventh and eighth seasons of existence in large part due to the stellar goaltending of Bernie Parent. Parent won the Smythe Trophy as playoff MVP during both of those championship runs as well as the Vezina Trophy as the league's best goalie in 1974 and 1975. In the 1980s, the Flyers also had a pair of tremendous netminders in Pelle Lindbergh and Ron Hextall. Lindbergh won the Vezina Trophy in 1985 and played in two NHL All-Star Games. Hextall won the Vezina Trophy and Smythe Trophy in 1987 and was voted the Flyers' MVP three times.

Since the 1990s though, it has been a constant goalie shuffle in the Flyers' crease, as this position seemed to be their Achilles heel in pursuit of the Stanley Cup. Numerous goalies were brought for a year or two in the hopes being the missing ingredient.

The focus in this section is on the masked men who are the last line of defense. It is widely considered the most important position on a hockey team.

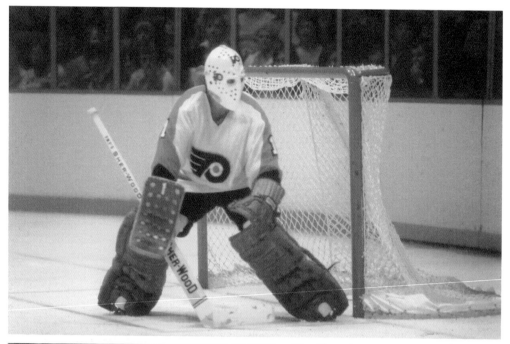

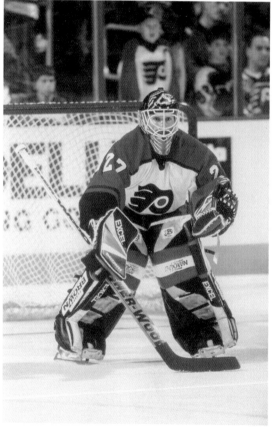

The Flyers have won two Stanley Cup Championships, and superstar goaltender Bernie Parent was instrumental in each of them. He was named the winner of the Conn Smythe Trophy as playoff MVP each time. He is considered the greatest Flyers goalie of all time and one of the greatest the NHL has ever seen. (Courtesy of the Philadelphia Flyers.)

Ron Hextall was a fiery, aggressive goaltender who came into the league and helped revolutionize the game. Hextall loved to play the puck, which was unusual at the time and was almost like a third defenseman. He also liked to clear the crease and was not shy about slashing an opposing forward who was trying to screen him. He recorded four seasons with 100-plus penalty minutes. (Courtesy of the Philadelphia Flyers.)

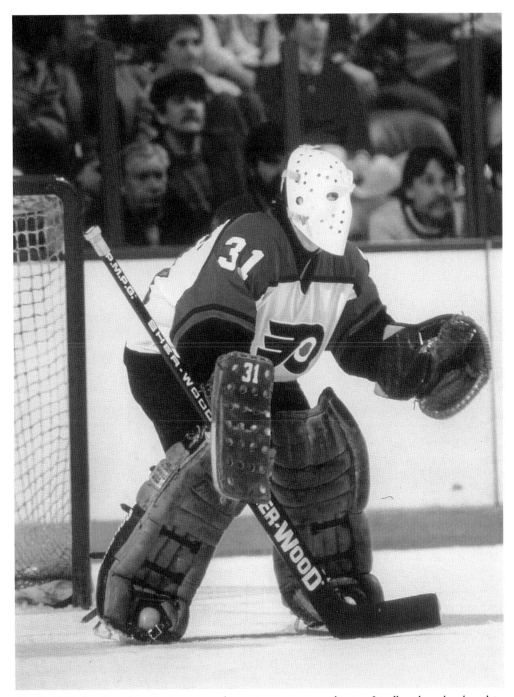

Goalie Pelle Lindbergh waits in net as the action comes up the ice. Lindbergh only played in 157 games as a Flyer, but his impact on the team was so much more. He was selected to the NHL All-Rookie Team in 1983, won the Vezina Trophy in 1985, played in the NHL All-Star Game in 1983 and 1985, and was selected for the 1986 game after his death. (Courtesy of the Philadelphia Flyers.)

Superstar goaltender Bernie Parent addresses the crowd in November 2010 prior to the demolition of the Spectrum. Parent, a charismatic individual, captivated those in attendance, as he recounted the great times the Flyers had in that building. The Flyers played in the Spectrum from their inception in 1967 until 1996. (Photograph by Mike del Tufo.)

Goalie Marty Biron came to the Flyers via a trade with the Buffalo Sabres in 2007. He was instrumental in helping the team go from one of the league's worst teams in 2006–2007 to the Eastern Conference Final in 2007–2008. He had a record of 30-20-9 that season with a .918 save percentage. (Photograph by Joe del Tufo.)

Goalie Roman Cechmanek's stint as a Flyer was a very memorable one. Generally speaking, goalies are known to be quirky and unusual. Cechmanek personified those characteristics. Every game seemed like an adventure with him in net. One game, he left the crease and checked an opposing player. It was also not uncommon for him to headbutt a puck, which garnered many nicknames including the "Cranium Carom." (Photograph by Drew King.)

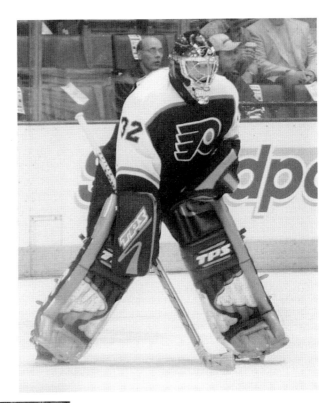

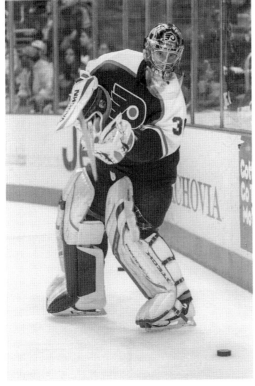

Goalie Antero Niittymäki was a later-round draft pick that worked out well for the Flyers. The Finnish player was picked 168th overall in the 1998 NHL Entry Draft and played four seasons with the club. He came up through the Flyers' system helping the Phantoms win the AHL Calder Cup Championship in 2005. He was named the MVP of the playoffs that season. (Photograph by Joe del Tufo.)

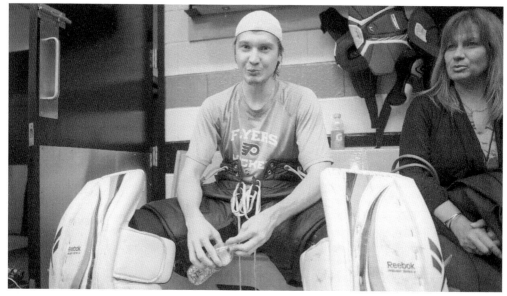

Sergei Bobrovsky was the surprising choice as the starting goaltender for the Flyers' inaugural game of the 2010–2011 season. He was never drafted and was signed as a free agent the previous summer. In this game, which was his NHL debut, he recorded a 3-2 win over the Flyers' hated rival the Pittsburgh Penguins. It was also the first game for the Pens in their new arena. (Photograph by Joe del Tufo.)

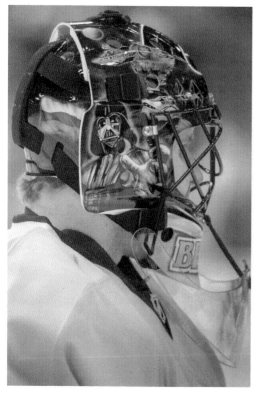

Russian goalie Ilya Bryzgalov played only two seasons for the orange and black, but his tenure in net was very memorable. Unfortunately, it was as much for his wackiness off the ice as his play on it. In this picture, he displays his new goalie mask with Darth Vader on the right side of it. (Photograph by Joe del Tufo.)

Flyers goalie Ilya "the Universe" Bryzgalov had a love-hate relationship with the Philadelphia media. Bryzgalov was known for speaking his mind and sometimes saying quirky comments that inevitably found their way to print. He played two erratic seasons for the team that were consistently memorable. In this picture, Bryzgalov shares a lighthearted moment with the press after a big win. (Photograph by Joe del Tufo.)

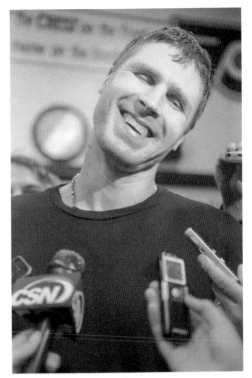

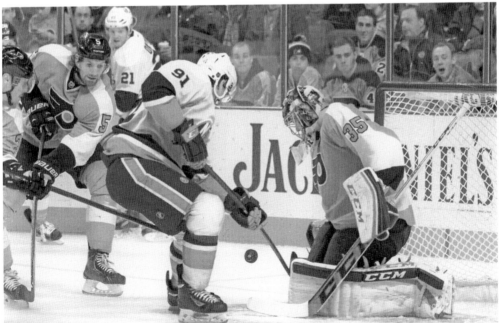

John Tavares of the New York Islanders looks to corral the puck in front of the Flyers' net, and Flyers goalie Steve Mason tries to stop him. Tavares is on his way to being an elite player in the NHL. He has scored 24-plus goals in each of his six seasons in the league and finished the 2014–2015 NHL season one point short of winning the Art Ross Trophy. (Photograph by Drew King.)

Flyers goaltender Steve Mason is focused and ready for action as play comes into the Flyers' defensive zone. Mason took the league by storm winning the Calder Memorial Trophy as rookie of the year in 2009 while playing for the Columbus Blue Jackets. However, he struggled after that until being traded to the Flyers in 2013 and regaining his impressive form. (Photograph by Joe del Tufo.)

Goalie Michael Leighton was an improbable choice to take the Flyers to 2010 Stanley Cup Final. He was claimed on waivers in December 2009. He found himself in the lineup quite a bit as injuries mounted for the club. He played very well and earned numerous starts the rest of the way. In the Eastern Conference Final, he allowed only seven goals in five games. (Photograph by Drew King.)

5

PLAYOFFS

Everything is more critical once the Stanley Cup Playoffs start. The intensity is greatly amplified. Every series represents a possible end to the season for each team. The stakes have been raised significantly. Some teams wilt under the pressure while others prosper.

The Flyers have met with their share of postseason successes with two Stanley Cup Championships and six other trips to the Stanley Cup Finals. During their most recent trip to the final in 2010, they overcame an almost insurmountable obstacle when they bounced back from a 3-0 deficit in a best-of-seven series against the Boston Bruins in the second round. This feat had not been accomplished since 1975. It is already an important part of the Flyers' playoff lore, especially coming against a classic rival.

Some top playoff performers for the Flyers include Bernie Parent, Bobby Clarke, Reggie Leach, Bill Barber, Dave Poulin, Brian Propp, Tim Kerr, Eric Lindros, Rod Brind'Amour, John LeClair, Keith Primeau, Simon Gagne, Jeremy Roenick, Danny Briere, Claude Giroux, and Ron Hextall.

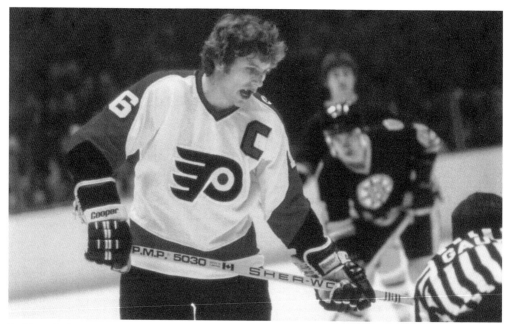

Bobby Clarke's name is synonymous with the Philadelphia Flyers. He was the team's longtime captain as well as its longtime general manager. While with the team, he won two Stanley Cups, was a three-time Hart Memorial Trophy winner, had three 100-point seasons, twice led the league in assists, and played in eight NHL All-Star Games. He was inducted into the Hockey Hall of Fame in 1987. (Courtesy of the Philadelphia Flyers.)

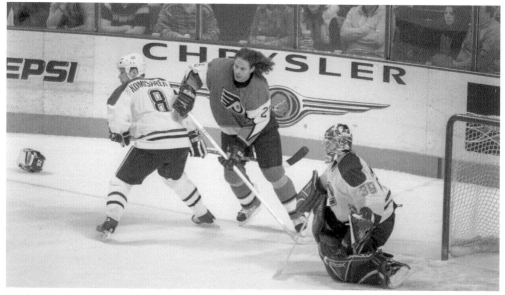

Michal Handzus was a crowd favorite in Philly for his consistent two-way play. He was especially strong on the penalty kill and known for his smart play. During his three-season stint with the Flyers, it was common for the crowd to chant his nickname, "Zeus." In this picture, the Slovakian battles for position in a game against the Montreal Canadiens. (Photograph by Joe del Tufo.)

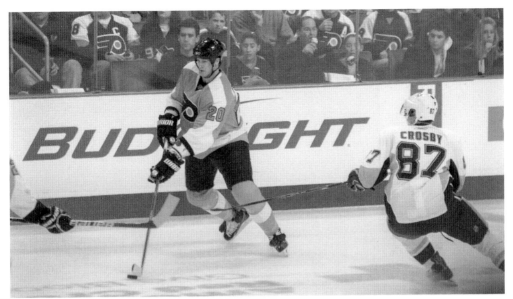

Flyers defenseman and future Hall of Famer Chris Pronger stickhandles around hated foe Sidney Crosby of the Pittsburgh Penguins. Crosby, since his debut with the Penguins in 2005, has been public enemy No. 1 in the City of Brotherly Love. No opposing player is booed with more veracity than Crosby. Pronger was the Flyers 18th captain. His NHL career unfortunately ended while with the Flyers due to post-concussion syndrome. (Photograph by Joe del Tufo.)

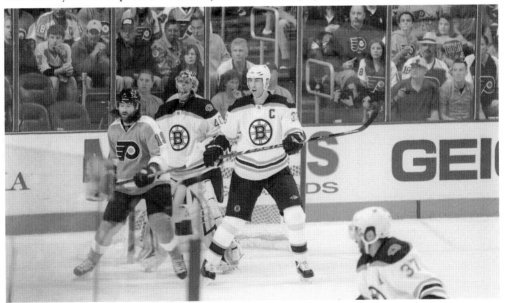

A task does not get much bigger than having to deal with huge Boston Bruins defenseman Zdeno Chara in front of the net. Flyers Scott Hartnell not only faced that challenge, but his team was down 0-3 in a seven-game series in the 2009–2010 playoffs. Hartnell would record an assist in this game as the Flyers won 5-4 in overtime, and they won the next three games to take the series. (Photograph by Joe del Tufo.)

THE PHILADELPHIA FLYERS

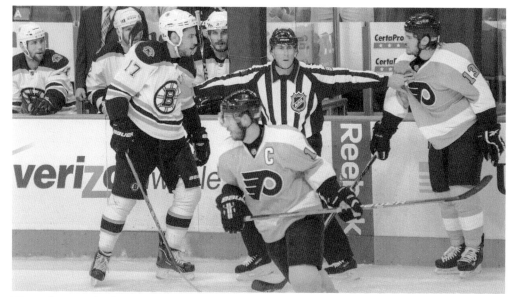

The stakes were high as the Philadelphia Flyers and the Boston Bruins were battling in a second-round playoff series. Neither Dan Carcillo of the Flyers nor Milan Lucic of the Bruins are reluctant combatants when it comes to a physical confrontation in a regular hockey game much less one with this gravity. But with a linesman squarely between them, any skirmish between the two was going to have to wait for another time. (Photograph by Joe del Tufo.)

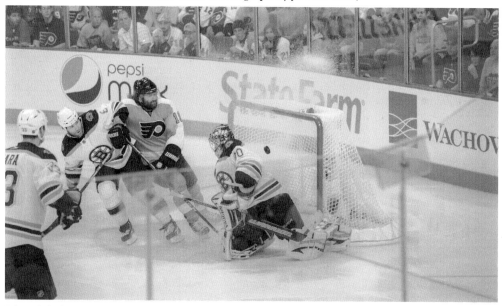

The Philadelphia Flyers were fighting for their playoff lives as they were down 3-0 in a best-of-seven series against the Boston Bruins. The Flyers had no quit in them and fought back against seemingly impossible odds. In this picture, Flyers forward Scott Hartnell tries to finish off a prime scoring chance, battling a Bruins defender as well as Bruins goalie Tuukka Rask. (Photograph by Joe del Tufo.)

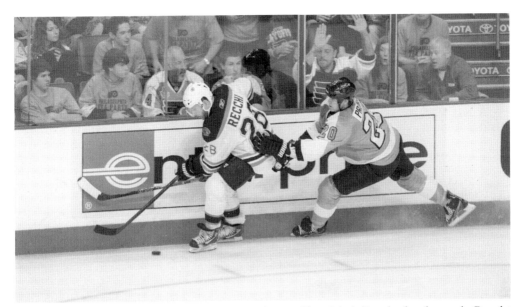

Flyers defenseman Chris Pronger battles with former Flyer Mark Recchi for the puck. Recchi had two long stints with the Flyers and is eighth all-time on the Flyers' career scoring list with 627 points. He also holds the Flyers' record for most points in a season. He accomplished that during the 1992–1993 season, when he scored 123 points on 53 goals and 70 assists. (Photograph by Joe del Tufo.)

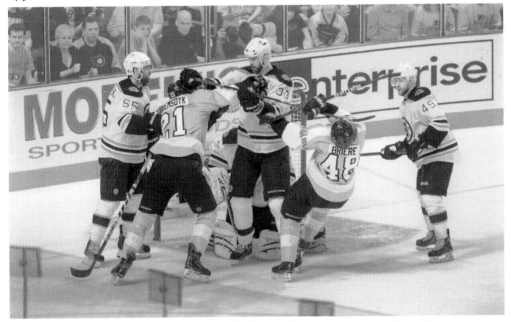

Six-foot-nine defenseman Zdeno Chara of the Boston Bruins is as immovable a player as there is in the NHL; however, that did not stop Flyers James van Riemsdyk and Daniel Briere from trying in this crucial playoff game in 2010. The Flyers no-quit attitude helped them win this game and come back from three games down to win this series. (Photograph by Joe del Tufo.)

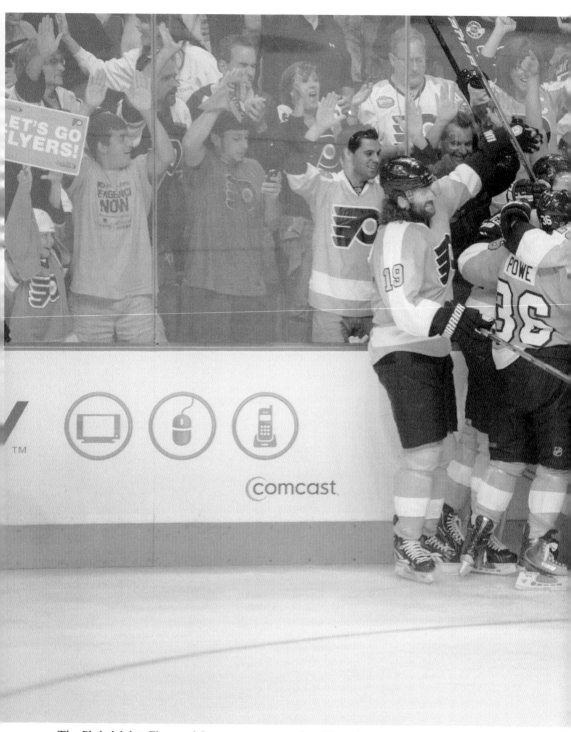

The Philadelphia Flyers celebrate an overtime playoff goal by winger Simon Gagne to give them an improbable win over the Boston Bruins. They went into Game 4 of this series trailing three games to none, and this goal helped them stave off elimination. The Flyers went on to complete a

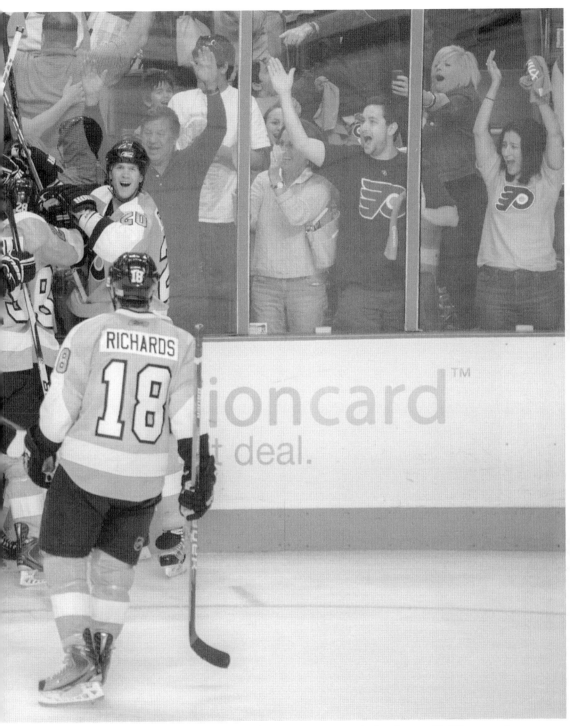

historic comeback, as they would win the next three games to stun the hockey world. (Photograph by Joe del Tufo.)

Danny Briere was a huge reason the Philadelphia Flyers made a great run at the Stanley Cup in 2010. During that season Briere had 30 points in 23 games, to lead the team. He played six memorable seasons in the City of Brotherly love. The fast-skating center and his kids still live locally in South Jersey. (Photograph by Mike del Tufo.)

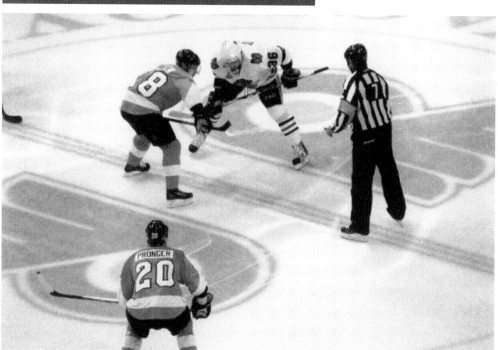

Dave Bolland and the Chicago Blackhawks face-off against Danny Briere and the Philadelphia Flyers on June 2, 2010. At the time, the Flyers were down 0-2 in the series, but they would win this one 4-3 in overtime. They did eventually drop the series 4-2 when the Blackhawks celebrated their Stanley Cup win on Flyers ice. (Photograph by Mike del Tufo.)

The acquisition of Chris Pronger was the single biggest reason the Philadelphia Flyers advanced to the Stanley Cup Final in 2010. He and his famous elbow-punished players in the corner and generally patrolled the crease to perfection. In 2010, the massive defenseman kicked in 18 points. Unfortunately, the 2011–2012 season was his last in the National Hockey League due to post-concussion syndrome. (Photograph by Mike del Tufo.)

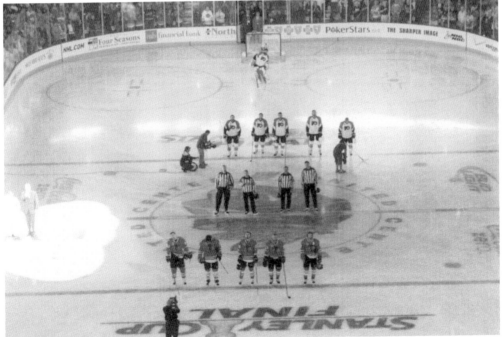

On May 29, 2010, the Philadelphia Flyers opened up the Stanley Cup Final in Chicago. The series was hard-fought, and the Flyers were not "just happy to be there." They eventually lost the series in six, and the Blackhawks won their first Stanley Cup Championship since 1961. It would not be their last. (Photograph by Mike del Tufo.)

Philadelphia Flyers captain Mike Richards had more than a few face-offs against Chicago Blackhawks center Dave Bolland. Both were tenacious on draws, and neither would give an inch. This took place in Chicago, and it is anybody's best guess who won this battle—their first of many rattlings of sabers. (Photograph by Mike del Tufo.)

Ian Laperrière was tough as nails. On April 22, 2010, "Lappy" blocked a puck with his face in the playoffs against the New Jersey Devils. He missed considerable time for this injury, not returning until Game 4 of the Eastern Conference Final against the Montreal Canadiens, where he helped the Philadelphia Flyers get the 4-1 series win. (Photograph by Mike del Tufo.)

6

CELEBRITIES

Philadelphia is one of the top hockey towns in the United States and the Flyers have been a top draw almost since they joined the NHL. When celebrities come to town, it is not uncommon for them to want to catch a game. The fast pace and rough style of the Flyers attract sports fans from all backgrounds.

When Sylvester Stallone was in town filming one of the Rocky sequels, he found time to head to Broad Street to watch a game. When Sarah Palin was campaigning to be vice president of the United States, she dropped the puck to start a Flyers and New York Rangers game. One never knows who may be in the crowd at the Wells Fargo Center when the orange and black are playing. A number of celebrities vocally consider themselves fans of the Flyers.

Philadelphia may not be Hollywood, but it still has its fair share of homegrown celebrities as well as luminaries just visiting who enjoy taking in an exciting game of Flyers hockey.

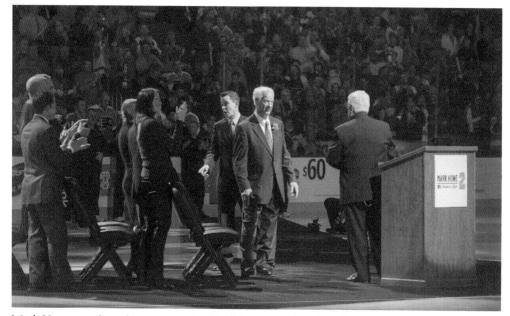

Mark Howe may have been getting his No. 2 hung to the rafters, but Gordie Howe was there not to upstage his son; he was there to support him. However, and Mark can attest to this, wherever Gordie goes, so do the cameras and the applause. The Flyers' longtime public address announcer Lou Nolan had the honors, as he did many times before. (Photograph by Joe del Tufo.)

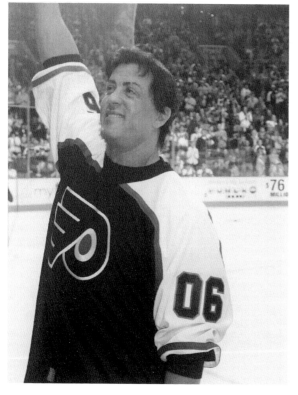

Sylvester Stallone is a well-known actor whose credits include several *Rocky* movies, about an underdog boxer named Rocky Balboa from Philadelphia who becomes heavyweight champion. Stallone took some time from filming one of the Rocky movies to visit and engage the crowd at a Flyers game. (Courtesy of the Philadelphia Flyers.)

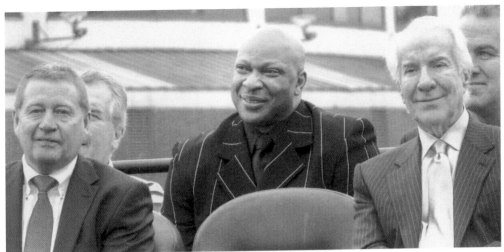

Former players attend the demolition of the Spectrum, the longtime home of the Flyers and 76ers. Included was the former 76er World B. Free (center) who played for the franchise from 1975 to 1978 and then from 1987 to 1988. The Sixers drafted him in the second round of the 1975 NBA Draft. He is currently an ambassador for the team. In this photograph, Flyers president Peter Luukko is on the left, and Flyers owner Ed Snider is to the right. (Photograph by Mike del Tufo.)

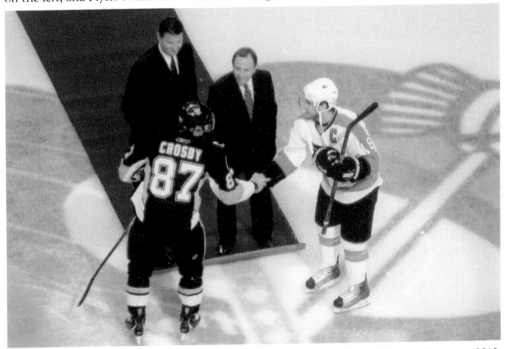

The Flyers helped open the Pittsburgh Penguins' new arena the Consol Energy Center in 2010. NHL commissioner Gary Bettman and NHL legend Mario Lemieux were present at the ceremonial opening face-off. In this picture, the Pens' Sidney Crosby and the Flyers' Mike Richards shake hands as Bettman (right) and Lemieux look on. The Flyers skated to a 3-2 victory in this game. (Photograph by Mike del Tufo.)

David Boreanaz, a well-known actor who has starred in TV shows *Bones*, *Angel*, and *Buffy the Vampire Slayer*, is an avid hockey fan and attends many NHL games every season. He is also a Flyers' fan whose father is a well-known Philly weathercaster. In this picture, Boreanaz is at the 2008 NHL All-Star game in Atlanta wearing a Flyers T-shirt. (Photograph by Mike del Tufo.)

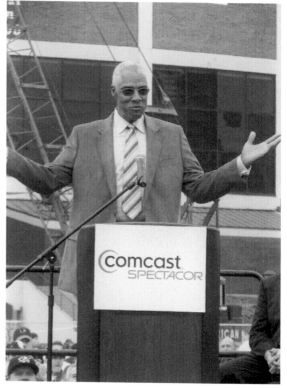

Julius "Dr. J" Erving is generally considered the greatest 76er ever. He led the team to the NBA Championship in 1983 and to three other trips to the finals. He was in attendance at the ceremony preceding the demolition of the Spectrum. Here, he speaks to the crowd and remembers all the big games contested at this renown venue in South Philly. (Photograph by Mike del Tufo.)

The Flyers battled the Tampa Bay Lightning in the Eastern Conference Final of the 2004 NHL Playoffs. The Lightning had a huge presence in wrestler Hulk Hogan in their corner for this titanic series, with the winner heading to the Stanley Cup Final. Hogan is a multiple-time World Wrestling Entertainment (WWE) champion and is considered a legend in his sport. (Photograph by Mike del Tufo.)

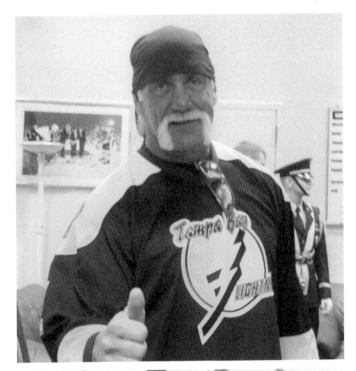

Donald Fehr rose to fame defending major league baseball players for many years. Never one to miss an opportunity to litigate, he did eventually leave this job. When the NHL locked out its players in 2012, Fehr came to their aid and became the executive director of the National Hockey League Players' Association (NHLPA). He is the only executive director of two playing unions to be involved in two work stoppages. (Photograph by Mike del Tufo.)

Lauren Hart is the renowned, longtime national anthem vocalist for the Flyers, as well as the daughter of Gene Hart, the voice of the Flyers for 29 years. Her rendition of "God Bless America," which she performs as a video duet with the late Kate Smith, is especially memorable and typically performed at pivotal regular season and playoff games. (Photograph by Joe del Tufo.)

Then Republican vice presidential candidate Sarah Palin dropped the ceremonial first puck at the Wachovia Center as the 2008–2009 season got underway. Mike Richards of the Philadelphia Flyers and Scott Gomez of the New York Rangers met Palin at center ice. In this game, the Flyers found themselves at quite an early disadvantage as their hated foes, the Rangers, scored four goals in the first period. They battled back but still lost 4-3. (Photograph by Mike del Tufo.)

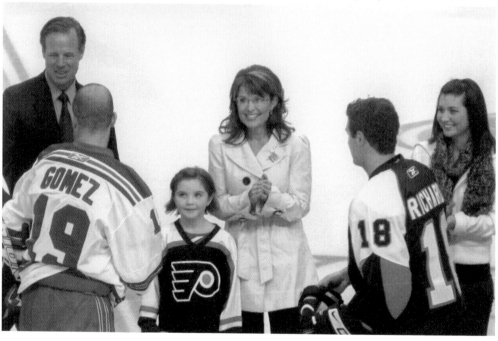

CELEBRITIES

7

MILESTONES

The Philadelphia Flyers have celebrated many milestones with the two Stanley Cup Championships in 1974 and 1975 being the most prestigious ones.

Many Flyers have won major NHL Awards. Bobby Clarke and Eric Lindros have both won the Hart Memorial Trophy given to the league's MVP. Bernie Parent, Pelle Lindbergh, and Ron Hextall have all won the Vezina Trophy as the league's top goalie. Parent, Reggie Leach, and Hextall have all won the Smythe Trophy as the playoff's MVP. Clarke and Dave Poulin won both the Frank Selke Trophy as the league's top defensive forward. Several have also received the incredible honor of being inducted in the Hockey Hall of Fame, including Clarke, Parent, Bill Barber, Ed Snider, and Mark Howe.

The Flyers have had a number of great players put on their jersey and achieve greatness. This section consists of photographs depicting a historic moment by a player or the team.

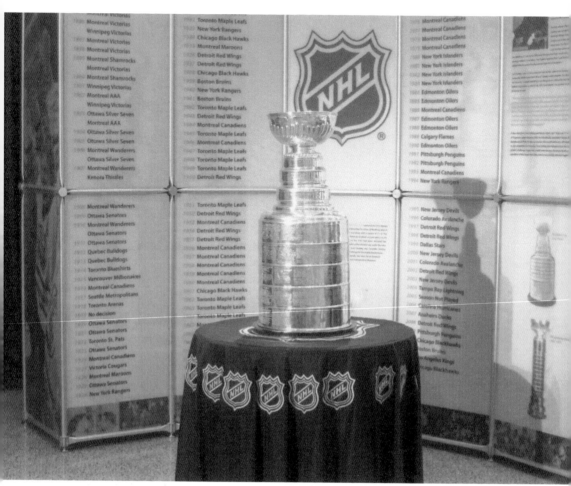

The Stanley Cup travels more miles than most pilots do. It makes one wonder if Lord Stanley of Preston knew that the cup that he purchased in London for around $50 back then would arguably be the greatest trophy in organized sports. The original cup does not travel, but the legacy and tradition have continued. Fans watch the news intently over the summer to see some of the cool places "Stanley" visits. (Photograph by Mike del Tufo.)

Ron Hextall is most remembered for being the first NHL goaltender to score a goal by shooting the puck into the opponent's empty net. He did that against the Boston Bruins in the 1987–1988 season. He repeated the feat the following season in the playoffs against the Washington Capitals. Hextall also won the Vezina Trophy as top goalie and the Conn Smtyhe as playoffs MVP during the 1986–1987 season. (Courtesy of the Philadelphia Flyers.)

Pelle Lindbergh won the Vezina Trophy as the NHL's top goaltender following the 1984–1985 season. He recorded 40 wins for the Flyers during the regular season and added 12 more in the playoffs as the team advanced to the Stanley Cup Final that season. (Courtesy of the Philadelphia Flyers.)

When one covers the Stanley Cup, sometimes "Lord Stanley" pops up in the strangest places. This time it was hiding in plain sight in Vancouver. While the locals had an idea that their team would be against the Bruins, one intrepid reporter decided to take a picture of the Flyers championship rings. (Photograph by Mike del Tufo.)

Philadelphia Phantoms goaltender Antero Niittymaki is pictured holding the Jack A. Butterfield AHL playoff MVP Trophy in 2005. The Phantoms beat the Chicago Wolves 4-0, who were led by a countryman, netminder Kari Lehtonen. Philadelphia fans had something to cheer about during the NHL's lockout season. This was the last time the Phantoms won a title. (Photograph by Mike del Tufo.)

The Broad Street Bullies celebrated two Stanley Cup titles in 1973–1974 and 1974–1975. In today's NHL, this is almost an impossible task. Many readers never had a chance to see these teams play live. The Philadelphia Flyers do a great job of celebrating their championship seasons so future fans can look back on them with pride and future teams have something to shoot for. (Photograph by Mike del Tufo.)

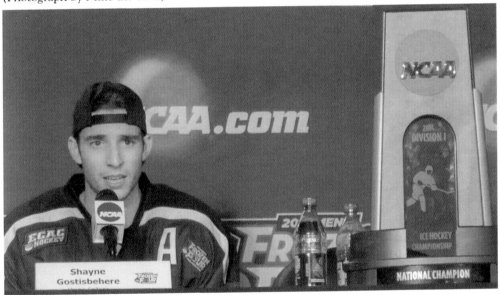

In 2014, the NCAA Frozen Four was held at the Wells Fargo Center. The Union College Dutchman faced off against the Minnesota Golden Gophers for all the marbles. Union won 7-4, and the Flyers 78th overall pick in 2012, defenseman Shayne Gostisbehere, was the man of the hour. Flyers fans were elated that "one of their own" had won a championship and were hopeful he could someday lead the Flyers to a Stanley Cup Championship. (Photograph by Mike del Tufo.)

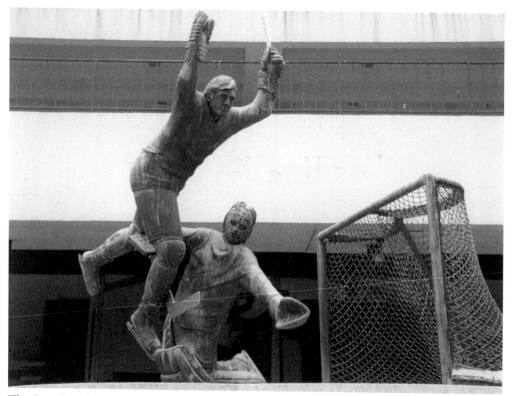

The Gary Dornhoefer statue was a mainstay at the now defunct Spectrum. This Philadelphia Flyers great scored a very important overtime goal against the Minnesota North Stars in the Stanley Cup Quarterfinals that put the Flyers up 3-2 in the series. They eventually won that series but lost in the semifinals to the great Montreal Canadiens. This goal put the former expansion team on the road to respectability. (Photograph by Mike del Tufo.)

On December 11, 1969, the Philadelphia Flyers started to play Kate Smith's rendition of "God Bless America" before their home game. When they started to win with it, the team played it more frequently. At the home opener on October 11, 1973, Smith surprised the crowd by singing in person. They won that game 2-0. She then appeared live in Game 6 of the Stanley Cup Final against the Boston Bruins. The Flyers shutout the Bruins 1-0 in that en-route to their first of two Stanley Cup Championships. (Photograph by Mike del Tufo.)

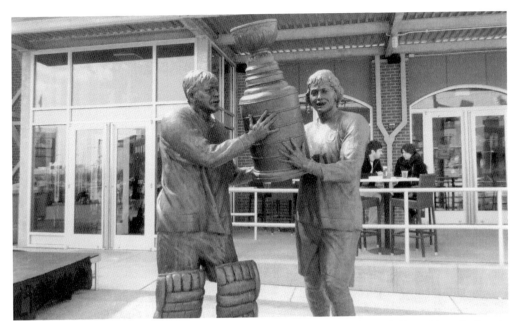

Having a statue of Philadelphia Flyers superstar captain Bobby Clarke and all-world goalie Bernie Parent passing the Stanley Cup to one another is an image that Philly sports fans could look at with reverence for many years to come. Both of them were huge factors in the back-to-back Stanley Cups victories. (Photograph by Mike del Tufo.)

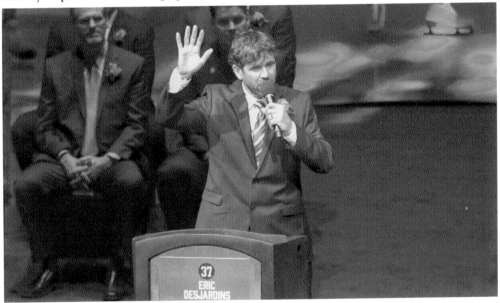

On February 19, 2015, Eric "Rico" Desjardins was inducted into the Philadelphia Flyers Hall of Fame. With a gaggle of Flyers luminaries looking on, the slick-skating defenseman got to wave goodbye to his adoring fans who had the pleasure of watching him in orange and black for 11 glorious seasons. He was one of the eighteen captains the Flyers have had in the history of the franchise. (Photograph by Amy Irvin.)

On a cold March night during the 2014–2015 season, Philadelphia Flyers forward Brayden Schenn thought he had a hat trick. As that goal went in, a large number of fans in the crowd gladly tossed their favorite hockey hat onto the ice. A few seconds later it was ruled that teammate Wayne Simmonds scored the first period goal that was originally awarded to Schenn. (Photograph by Amy Irvin.)

NHL players are as much fans of hockey as any of its regular fans are. In this picture, Flyers Claude Giroux has his jersey signed by Patrik Elias of the New Jersey Devils in the locker room following the 2011 NHL All-Star Game in Raleigh, North Carolina. Alexander Ovechkin of the Washington Capitals is poised to sign Giroux's jersey next. (Photograph by Fran Rubert.)

James van Riemsdyk, who was the Philadelphia Flyers' first-round pick (No. 2 overall) in the 2007 NHL Entry Draft, scored his first NHL goal in his 6th NHL game on October 24, 2009. He also added an assist in a 5-1 home victory over the Florida Panthers. Van Riemsdyk, nicknamed "JVR," stands proudly with the puck he deposited into his first NHL net. (Photograph by Mike del Tufo.)

The Flyers drafted Claude Giroux in the first round of the 2006 NHL Draft. He made his debut for the team in 2008. The 2010–2011 season was the breakout season for this speedy winger. He ended up scoring 25 goals and 76 points. During this season, he was selected to participate in his first NHL All-Star Game. Giroux meets with the press in this photograph. (Photograph by Fran Rubert.)

A young Claude Giroux is interviewed in the Flyers' locker room. Even though Giroux was a first-round draft pick in 2006, his promotion from the Phantoms, the Flyers' AHL affiliate, to the parent club was not met with much fanfare. He joined the team mid-season and did not make an immediate impact with the club. He scored nine goals in 42 games during the 2008–2009 season. (Photograph by Mike del Tufo.)

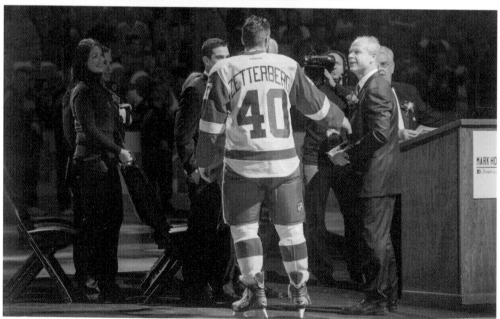

On March 6, 2012, Mark Howe became the fifth member of the orange and black to have his number retired and hoisted in the rafters. On that night, the Detroit Red Wings, Howe's current employer, were in town. All-Star Henrik Zetterberg wished Howe well, as he also wore the winged wheel in his playing days. (Photograph by Joe del Tufo.)

8

WINTER CLASSIC

The Winter Classic breathed new life into the NHL after a bitter lockout robbed the sport of the 2004–2005 season. The NHL had previously had several outdoor games. In 2008, the organization claimed New Year's Day as the day it would have two NHL teams battle in an outside stadium.

The Flyers had the opportunity to be one of the participants in the third Winter Classic in 2010. They faced off against the Boston Bruins in Fenway Park in Boston, a thrilling game that required overtime for a finish. The Bruins won 2-1, but it was a great experience for the Flyers in front of such a huge crowd.

Two years later, the Flyers were selected to host the event. They played the New York Rangers at Citizens Bank Park, home of the Philadelphia Phillies, in front of over 45,000 people. This game was also a tremendous success, but the Flyers once again came up just short, losing 3-2

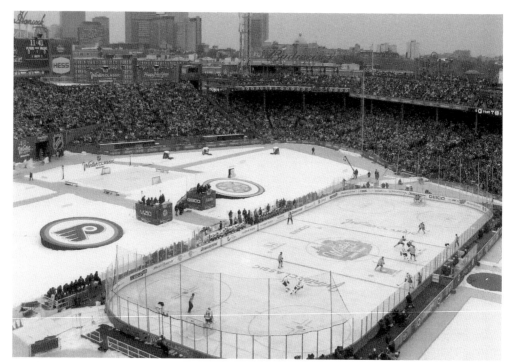

Here is a bird's-eye view of Fenway Park in Boston during play of the 2010 Winter Classic between the Flyers and Bruins. The Flyers held a late 1-0 lead until the Bruins tied it with 2:18 left in regulation on a power-play goal. The Bruins went on to win in overtime. Defenseman Danny Syvret, who played in only 37 games for the Flyers, scored the team's lone goal. (Photograph by Mike del Tufo.)

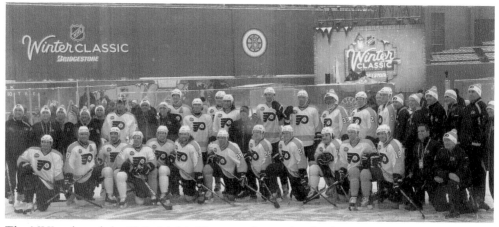

The NHL selected the Philadelphia Flyers to play in the third Winter Classic against one of their hated rivals from the 1970s, the Boston Bruins. The venerable Fenway Park in Boston was designated as the setting for this intriguing match-up. The animosity between these franchises had been renewed in recent years with some very physical games involving these two teams. Prior to the Flyers practice on this outdoor rink, they took a team picture at center ice. (Photograph by Mike del Tufo.)

While the Flyers practiced at Fenway Park in Boston in preparation for the third Winter Classic, goalie Brian Boucher donned a toque as some snow flurries came down. Boucher, a native of Woonsocket, Rhode Island, was not tabbed to be the starting goaltender for this game, but that did not damper his enthusiasm in being a part of this special event so close to where he is from. (Photograph by Mike del Tufo.)

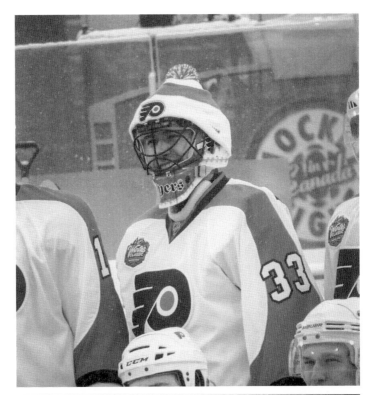

From left to right, Flyers forwards Ian Laperriere, Danny Briere, and Simon Gagne pose for a photograph during the practice prior to the Winter Classic in Boston in 2010. This was Laperriere's final season in the NHL and only season with the Flyers, but he made it very memorable. His fierce and rugged play resulted in many stitches, loss of teeth, and concussions but made him a crowd favorite. (Photograph by Mike del Tufo.)

Flyers captain Claude Giroux wears the Winter Classic jersey for this outdoor game in Boston in 2010. At this point in his career, Giroux had yet to play a full season in the NHL. He was just two weeks shy of his 22nd birthday. Giroux played on a line with Mike Richards and Simon Gagne in this special game. (Photograph by Mike del Tufo.)

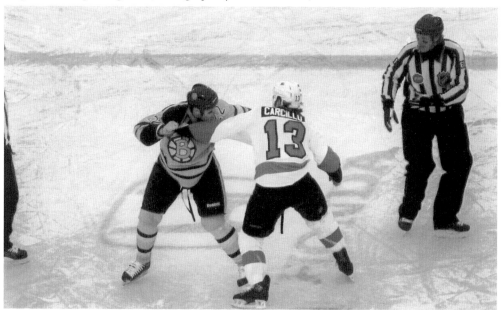

Not surprisingly, the Winter Classic finally had its first fight when the Flyers got involved. At 12:01 of the first period of the 2010 Winter Classic, Flyer Dan Carcillo and Bruin Scott Thornton, both well-versed in the rougher side of hockey, dropped the gloves. Afterwards, it was no doubt a weird feeling for both combatants when they got sent to the penalty box over near the pitcher's mound. (Photograph by Mike del Tufo.)

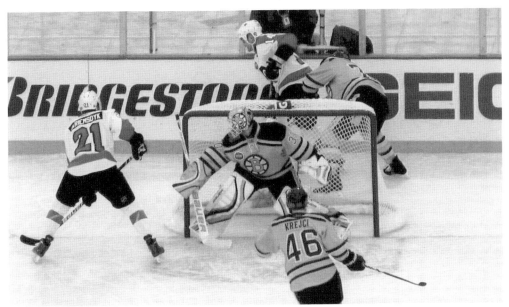

Flyers forward Ian Laperriere battles for the puck behind the Bruins' net at the 2010 Winter Classic in Boston. Fellow forward James van Riemsdyk readies near the net for a possible scoring chance. This was during van Riemsdyk's rookie season. He played in 99 games that season as the Flyers advanced all the way to Game 6 of the Stanley Cup Final. (Photograph by Mike del Tufo.)

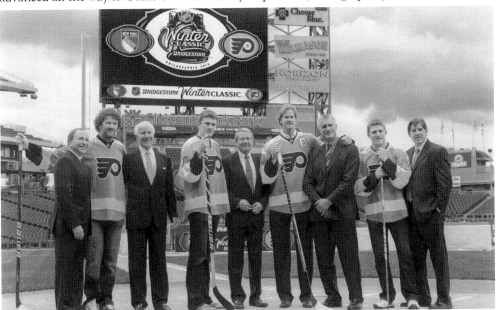

The NHL held a press conference in September 2011 to announce the Winter Classic on at Citizens Bank Park. Pictured from left to right are NHL commissioner Gary Bettman, Hartnell, Flyers owner Ed Snider, forward James van Riemsdyk, Flyers president Peter Luukko, defenseman Chris Pronger, Flyers general manager Paul Holmgren, defenseman Matt Carle, and Flyers head coach Peter Laviolette. This group shot followed the announcement. (Photograph by Joe del Tufo.)

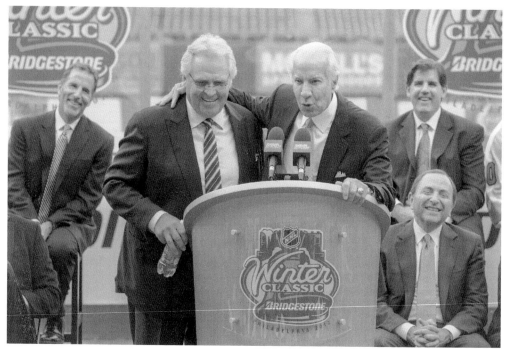

As the sun set on the summer of 2011, the New York Rangers and Philadelphia Flyers had a press conference at Citizens Bank Ballpark, home of the Phillies and the eventual 2012 NHL Winter Classic. Always a showman, Rangers general manager Glen Sather (left at podium) guaranteed a win in the game and a Stanley Cup Championship to boot. Flyers owner Ed Snider (right at podium) was clearly playing along, as was his head coach Peter Laviolette (upper right), Rangers head coach John Tortorella (left), and NHL commissioner Gary Bettman (lower right). (Photograph by Joe del Tufo.)

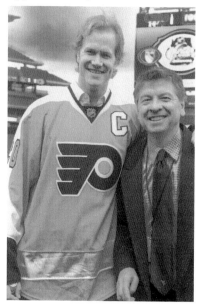

Defenseman Chris Pronger poses with Zack Hill, the senior director of communications for the Flyers, at the Winter Classic announcement in September 2011. It was held at Citizens Bank Park in Philadelphia several months before the Flyers and New York Rangers played an outdoor game there. Pronger was unfortunately unable to play in that game due to post-concussion syndrome. (Photograph by Joe del Tufo.)

Several months before the fifth Winter Classic, the NHL held a press event to promote it bringing players of both the Flyers and their opponent in this game, the New York Rangers, to the stadium. Defenseman Chris Pronger, then the captain of the Flyers, demonstrated his abilities with a baseball bat for those in attendance. (Photograph by Joe del Tufo.)

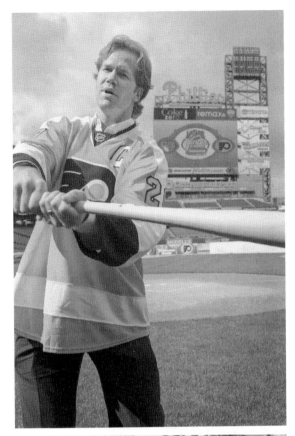

Former Philadelphia Flyer and current NBC analyst Jeremy Roenick had a chance to say hello to Danny Briere, who he once played against, at the practice the day before the 2012 NHL Winter Classic in the City of Brotherly Love. Neither wore orange and black at the same time, but there is a camaraderie that exists with Flyers alumni that does not occur in many other NHL franchises. (Photograph by Joe del Tufo.)

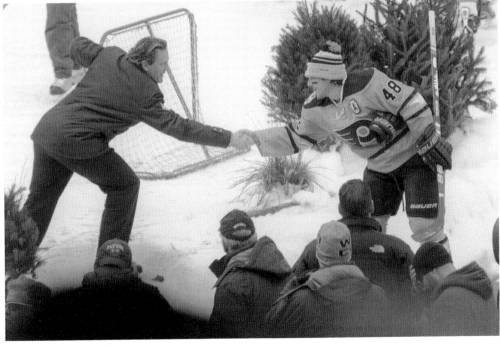

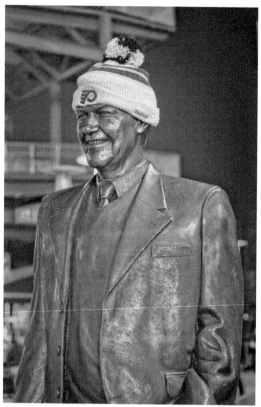

When one becomes a voice of a franchise, like Philadelphia Phillies television play-by-play man Harry Kalas did, he or she gets a bronze statue. This one is located outside Citizens Bank Park, and for the week of the 2012 NHL Winter Classic, Kalas donned a Philadelphia Flyers toque to commemorate the event. Had the Philadelphia Flyers or New York Rangers knocked a puck out of the rink, fans could imagine Kalas saying, "That puck is outta here." (Photograph by Joe del Tufo.)

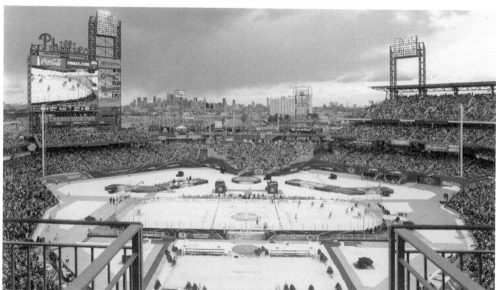

High above the Phillies ballpark while the New York Rangers were facing the Philadelphia Flyers in the 2012 Winter Classic, some members of the media were out in the cold of winter looking for that perfect stadium shot. With the beautiful Philadelphia skyline as the backdrop, this game had a lot of great elements. (Photograph by Joe del Tufo.)

WINTER CLASSIC

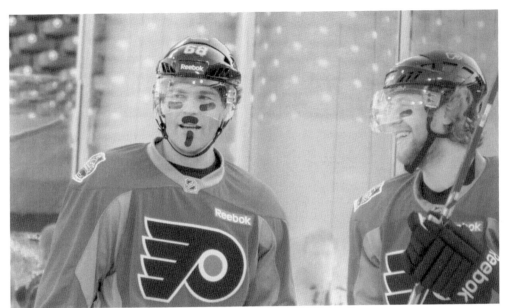

The fifth Winter Classic was hosted in Philadelphia at Citizens Bank Park. This was the first Winter Classic not played on January 1, as it was a Sunday and the league did not want to compete with the National Football League (NFL). The game was held on January 2. The Flyers held an outdoor practice on the day prior instead. Here, Jaromir Jagr entertains his teammates as the team prepares for the big game. (Photograph by Mike del Tufo.)

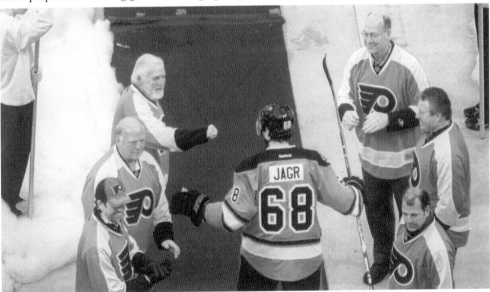

The Flyers battled the New York Rangers on January 2, 2012, in the fifth Winter Classic, which was held in Citizens Bank Park, home of the Phillies. In this picture, Flyers winger Jaromir Jagr makes his way toward the outdoor rink and is greeted by a number of well-known Flyers alumni. Former Flyer great Bernie Parent has extended his arm to give Jagr a fist bump. (Photograph by Mike del Tufo.)

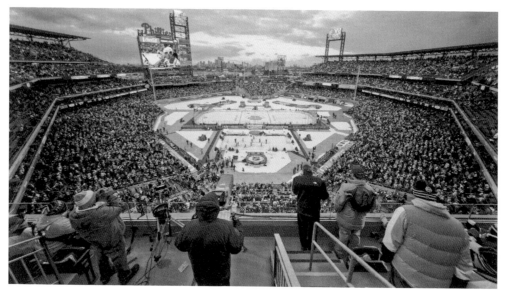

It was a breathtaking view from the upper deck at Citizens Bank Park in Philadelphia during the 2012 Winter Classic between the Philadelphia Flyers and New York Rangers. Citizens Bank Park has been the home of the Philadelphia Phillies of MLB since 2004 and saw the Phillies end a 28-year drought by winning the World Series there in 2008. (Photograph by Joe del Tufo.)

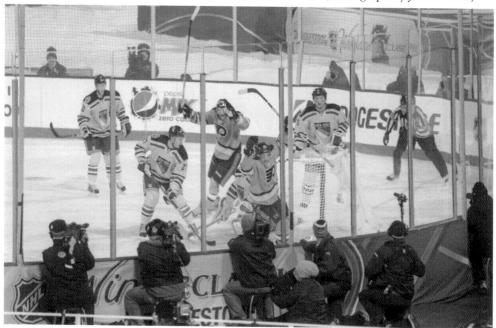

On January 2, 2012, the Philadelphia Flyers were the first team to score at 12:26 of the first period of the Winter Classic. Brayden Schenn got that goal against the New York Rangers, and he proudly held his hands high in the air to the crowd at the Phillies ballpark. The Flyers lost that game, but there were a lot of fun moments for the home crowd, including some snow flurries in the third period. (Photograph by Joe del Tufo.)

9

BEHIND THE SCENES

When fans visualize the Philadelphia Flyers, they typically see a rough-and-tumble squad of hockey players plying their trade on the ice. This chapter focuses on them after they have skated off of the ice. It focuses on players in a regular setting without a jersey on and a stick in hand.

It is very common to see players doing pregame and postgame interviews on television. Press conferences and media scrums are a daily event for many of these players, especially the more high-profile ones. Players often are seen in public away from the rink for events such as store signings and charity causes. The Flyers are very active in the community, frequently participating in charity events.

Photographs in this section spotlight the players when they are not performing in front of thousands of fans. Unlike the athletes of many other sports, hockey players seem less like rock stars and more like average people.

Rod Brind'Amour was eventually traded from the Philadelphia Flyers in 2000. The Flyers acquired future captain Keith Primeau, and the Hurricanes got a key player, who captained them in their 2006 Stanley Cup victory. Next stop is the Flyers Hall of Fame in 2015. (Photograph by Mike del Tufo.)

Rod Brind'Amour has the face of a hockey player. After games, he was consistently very cordial to the media, and for nine seasons, he was beloved by Flyers fans. He was acquired by Philadelphia in a trade with the St. Louis Blues in 1991 as a centerpiece in a deal that involved Ron Sutter and Murray Baron. (Photograph by Mike del Tufo.)

With a cold glassy stare, then general manager Paul Holmgren always entered the Flyers locker room to talk about injured players. That was never an easy time, and he never minced words but clearly had to bite his tongue more than a few times. The Philadelphia media can be relentless. (Photograph by Mike del Tufo.)

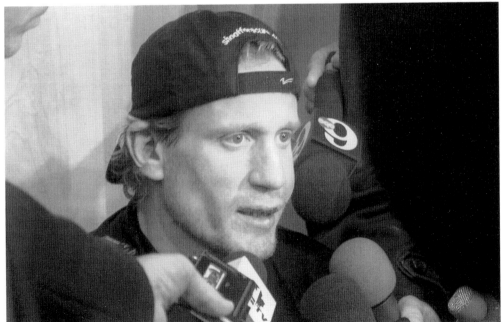

After a game, Jeremy Roenick holds court with the Philadelphia media at large. Never holding back, a trait that has gotten him a post-hockey job as an NBC in-studio host, meant there would be some great quotes, win or lose, for the various outlets in the Delaware Valley and Canada. (Photograph by Mike del Tufo.)

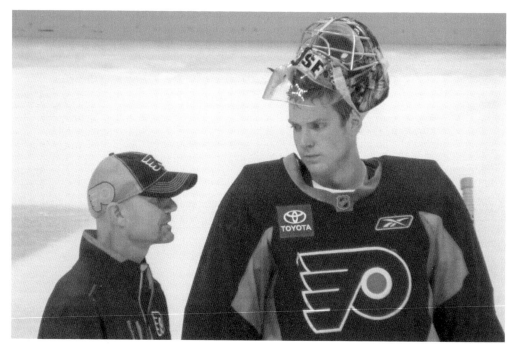

When the Philadelphia Flyers acquired Steve Mason from the Columbus Blue Jackets, many felt like this former Calder Memorial Trophy winner was trending downward. He finished the season strong in 2013 for the Flyers, and still, there were questions. The man credited with a lot of his success was goalie coach Jeff Reese. (Photograph by Mike del Tufo.)

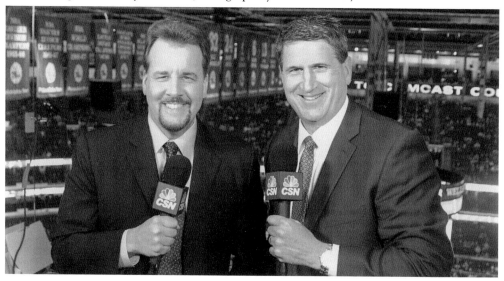

As pictured at the last home game of the 2014–2015 season, from left to right, Jim Jackson and Keith Jones are two big reasons that Philadelphia Flyers fans tune into CSN game after game. 2015 was Jackson's 20th season as the Flyers play-by-play voice. The day was April 7, 2015, and the Flyers beat the New York Islanders to close out their home schedule with a 5-4 win. (Photograph by Amy Irvin.)

Fran Rubert (pictured right), the founder of Center Ice Hockey Magazine, took great pride in getting fresh content and in-depth interviews to engage his readership. Simon Gagne (left) was always a fan favorite and a player who was media accessible. Both were proud hockey men. Rubert passed away too young, and Gagne announced his retirement in September 2015. (Photograph by Mike del Tufo.)

Roger "Captain Video" Neilson was the Flyers coach from 1998 through 2000. He was a simple man who had a love of hockey and dogs and would bike to the team's practice facility. Even when his bone cancer was advancing in 2000, he tried to convince the Flyers against doctors' orders that he was well enough to coach the second round of the playoffs. Besides his video replay legacy, he also was appointed a Member of the Order of Canada before he passed away. (Photograph by Joe del Tufo.)

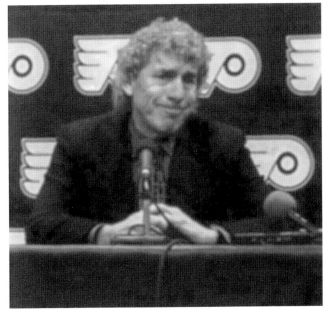

For decades now, as members of the media rush into their elevator on cold evenings, they can always count on Frank Kelly's friendly face and happy voice to greet them and ask if the Flyers can beat this team tonight. His job has its ups and downs, but he continues to endure because he has a love for the game. (Photograph by Joe del Tufo.)

Bruce "Scoop" Cooper is a Flyers historian who not only covered the team in the Spectrum, but also has been working with the NBC broadcast crew for many years as a right arm to Doc Emrick. He has seen virtually every hockey event in the new building since its construction. (Photograph by Joe del Tufo.)

BEHIND THE SCENES

Keith Primeau is remembered most for being a playoff hero for the Flyers. He scored the five-overtime goal in Game 4 of the second round of the 2000 Stanley Cup Playoffs against the Pittsburgh Penguins, and he carried the team in the 2004 playoffs, scoring nine goals in 18 games. He served as the team's captain from 2001 to 2006 before having to retire due to concussions. (Photograph by Mike del Tufo.)

Winger Ville Leino was largely an unknown player prior to the 2010 Stanley Cup Playoffs. He was acquired in a trade in February 2010 and scored two goals for the Flyers in 13 games. Then, in the playoffs, he scored 7 goals and 14 assists in 19 games. He was a big reason the Flyers advanced all the way to the Stanley Cup Final that season. (Photograph by Mike del Tufo.)

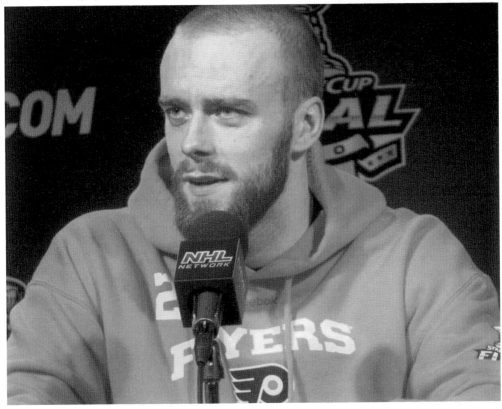

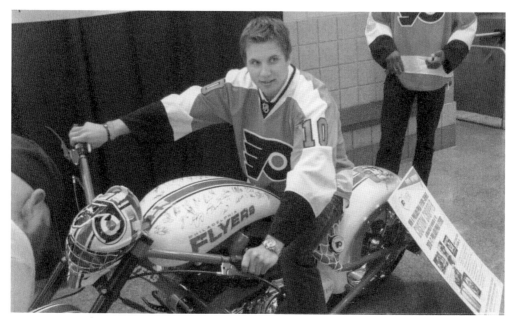

The Flyers acquired winger Brayden Schenn in a trade with the Los Angeles Kings in 2011. Schenn was the fifth pick in the 2009 NHL Entry Draft. Prior to him ever suiting up for the team, he participated in a charity event involving a motorcycle. He is pictured here at 19 years old, posing on the bike. (Photograph by Mike del Tufo.)

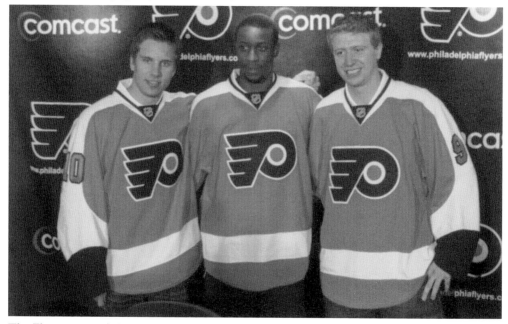

The Flyers acquired, from left to right, forwards Brayden Schenn, Wayne Simmonds, and Jakub Voracek in two big trades in June 2011. The team held a press conference at the Wells Fargo Center with all three shortly afterwards and then brought the trio to a charity auction to promote it. (Photograph by Mike del Tufo.)

BEHIND THE SCENES

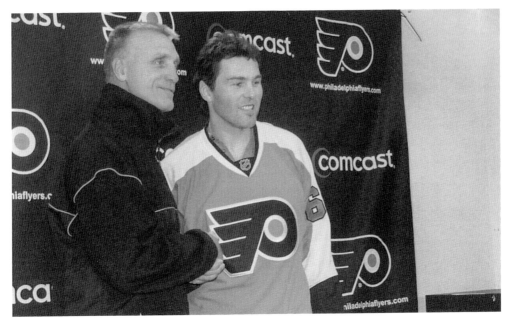

Future NHL Hall of Famer Jaromir Jagr decided to try on an orange-and-black jersey after 20 years in the league. Jagr had many options but was clearly enticed by the prospect of playing on the same line as Claude Giroux. Here, Flyers general manager Paul Holmgren poses with Jagr as he tries on his first Flyers jersey in July 2011. (Photograph by Fran Rubert.)

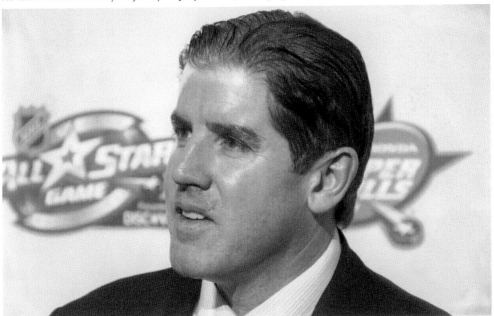

Flyers head coach Peter Laviolette represented the franchise at the 2011 NHL All-Star Game in Raleigh, North Carolina. It was a homecoming of sorts for Laviolette, as he had led the Carolina Hurricanes to the Stanley Cup in 2006. He was the Flyers' head coach from December 2009 until October 2013. (Photograph by Fran Rubert.)

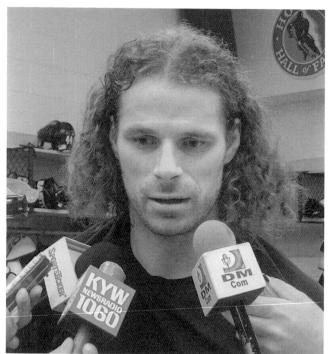

Forward Michal Handzus is interviewed in the locker room after a game. Handzus played three seasons for the Flyers from 2002 to 2004. He was a well-liked player who was solid at both ends of the ice. His career spanned 15 years, playing with five other organizations other than the Flyers. He won a Stanley Cup with the Chicago Blackhawks in 2013. (Photograph by Mike del Tufo.)

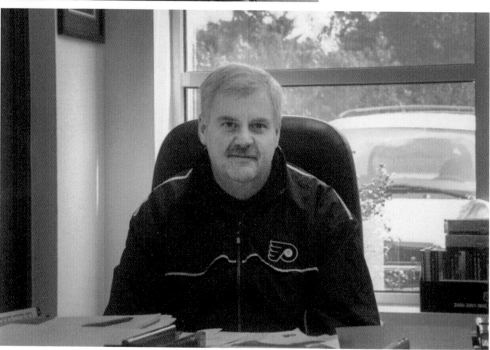

The Flyers hired Ken Hitchcock as their head coach in 2002. He had quite an impressive resume, as he had led the Dallas Stars to the Stanley Cup in 1999. Each of the three full seasons he coached the Flyers, they scored more than 100 points and qualified for the postseason. In this picture, Hitchcock sits in his office at the Flyers practice rink. (Photograph by Mike del Tufo.)

In 2005, it was huge news when the Flyers signed Peter Forsberg to a two-year contract. The Flyers had originally drafted him sixth overall in 1991. But before he could ever skate a shift in Philly, he was shipped off as a part of the Eric Lindros trade. As a member of the Colorado Avalanche, he had won two Stanley Cups and had become a superstar in the league. (Photograph by Mike del Tufo.)

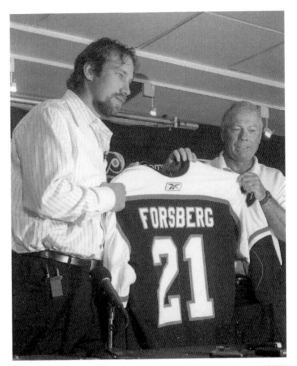

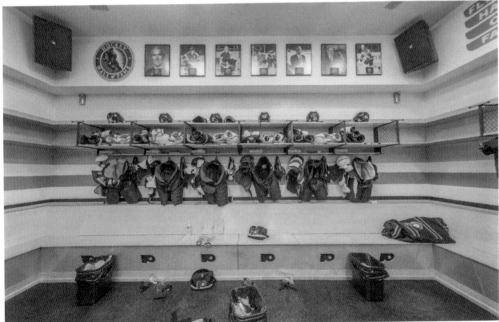

It is all quiet in the Flyers' locker room after another hard-fought game. This has been the Flyers' locker room since 1996, when they moved from the Spectrum. Numerous big names have suited up in this locker room, including Eric Lindros, Peter Forsberg, Ron Hextall, Jeremy Roenick, Chris Pronger, Mark Recchi, Claude Giroux, John LeClair, and Simon Gagne. (Photograph by Joe del Tufo.)

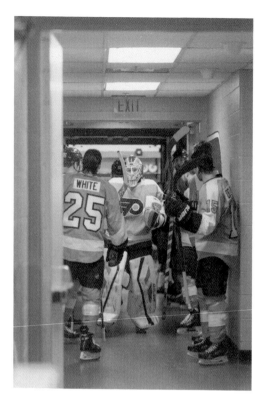

The Flyers group around the entrance to their locker room as they prepare to take the ice. It is where their leaders can provide some last-minute motivation to get the team pumped up for a big game. It is common to see high-fives and fist bumps as the team looks to come together and be a cohesive unit. (Photograph by Joe del Tufo.)

It is fairly common to see NHL players kicking around a soccer ball several hours before a game. At the Wells Fargo Center, they have another option, as management has set up a basketball net not far away from the Flyers' locker room. Flyers winger and current captain Claude Giroux tests his skills in another sport in this picture. (Photograph by Joe del Tufo.)

It was a sad day in November 2010 when the Spectrum was demolished. A lot of the famous players from both the Flyers and 76ers attended the ceremony prior to the wrecking ball hitting the arena. Pictured are the two most prominent Flyers in the history of the team: Bob Clarke (left) and Bernie Parent. (Photograph by Mike del Tufo.)

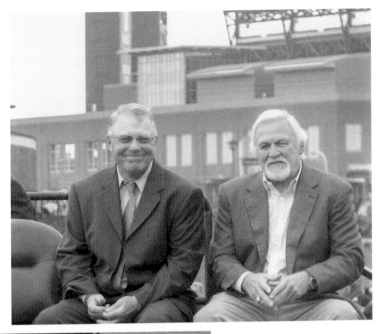

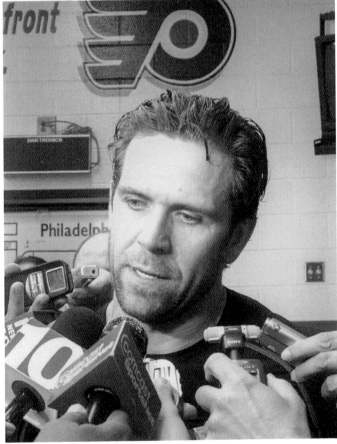

Defenseman Eric Desjardins had a tremendous career with the Flyers, playing for the team from 1995 to 2006. He won the team award for best defenseman (the Barry Ashbee Trophy) an impressive seven times. Prior to joining the Flyers, he also won the Stanley Cup with the Montreal Canadiens in 1993. He has the distinction of being the only defenseman to record a hat trick in a Stanley Cup Final. (Photograph by Mike del Tufo.)

Goalie Brian Boucher was a first-round draft pick of the Flyers in 1995. He went on to have three separate stints with organization. He was a popular player with his teammates and always had a lot of character. In this picture, he puts on the playoff beard that was given away to fans prior to a playoff game in 2010. (Photograph by Drew King.)

The Flyers selected goalie Anthony Stolarz in the second round (45th overall) of the 2012 NHL Entry Draft that was held in Pittsburgh. Stolarz was born not that far away from Philly in Jackson, New Jersey. Even though American, he opted to play Juniors in Canada, where he played two strong seasons for the London Knights of the Ontario Hockey League. (Photograph by Mike del Tufo.)

BEHIND THE SCENES

Defenseman Travis Sanheim is introduced to the NHL media soon after his selection at the 2014 NHL Entry Draft. In the first-ever NHL Draft held in Philadelphia, the Flyers selected Sanheim with their first pick (17th overall). This smiling youngster was born in 1996, the year the Wells Fargo Center, the Flyers' arena, opened. (Photograph by Mike del Tufo.)

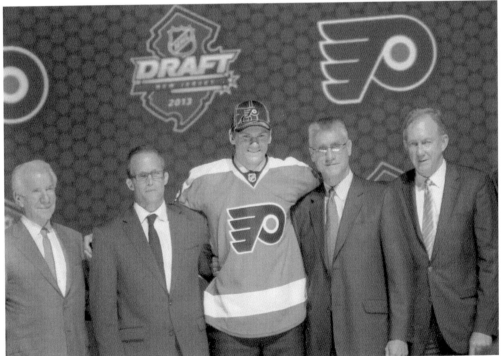

The Flyers were looking to get bigger on defense, so with the 11th pick in the 2013 NHL Entry Draft, they selected Samuel Morin. Morin, at six feet seven and 220 pounds, seemed to be exactly what they were looking for to help clear the crease. Morin, who was born in 1995, is expected to contend for a roster spot with the Flyers in the very near future. (Photograph by Mike del Tufo.)

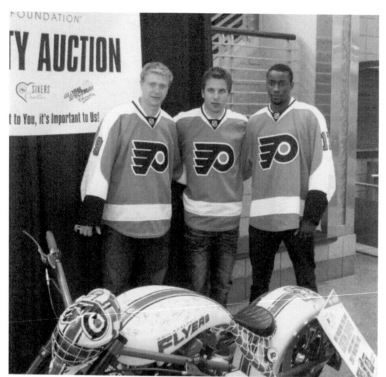

From left to right, Jakub Voracek, Brayden Schenn, and Wayne Simmonds all arrived in Philadelphia in June 2011 following a pair of trades that overhauled the look of the Philadelphia Flyers. Here, they participate in a charity event for the team prior to any of them actually lacing up their skates for the orange and black. (Photograph by Mike del Tufo.)

Wayne Simmonds reacts very lightheartedly following a rough game. The Flyers acquired Simmonds in a trade sending then captain Mike Richards to the Los Angeles Kings in June 2011. It was a blockbuster trade and a somewhat controversial one. Simmonds has proven to be quite a talented power forward, combining grit and a scoring touch. He has recorded several Gordie Howe hat tricks (a goal, an assist, and a fight) for the team. (Photograph by Joe del Tufo.)

The Flyers drafted Sean Couturier with eighth overall pick in the 2011 NHL Entry Draft. Couturier was expected to spend more time in the juniors, but his strong play in training camp won him a roster spot with the Flyers as an 18-year-old. Here, Couturier is spotted in the postgame locker room working on a playoff beard several weeks before the postseason began. (Photograph by Joe del Tufo.)

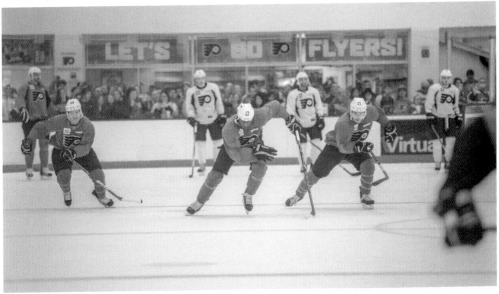

The 2012–2013 NHL season was unfortunately disrupted by a labor disagreement. An agreement was finally reached in January 2013. The fans mobbed the Flyers' practice facility upon their return. In this picture, from left to right, forwards Matt Read, Wayne Simmonds, and Scott Laughton race as the rest of the team and a jam-packed crowd watches. (Photograph by Joe del Tufo.)

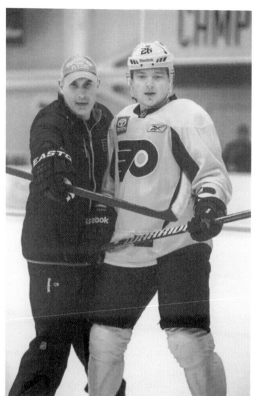

Former Flyer player and head coach Craig Berube works with Ruslan Fedontenko during practice. Berube had quite a long NHL career playing 1,054 games. He entered the league as a Flyer in 1987 and quickly gained a reputation as a rugged enforcer. He played 323 games in Philly, amassing 1,138 penalty minutes. He played for four other NHL clubs and retired with a career total of 3,149 penalty minutes. (Photograph by Joe del Tufo.)

On June 26, 2015, the Philadelphia Flyers drafted mega-talented defenseman Ivan Provorov with the seventh overall pick in Sunrise, Florida. The Russian blueliner can pile up the points on offense and play solid defense. He instantly became the No. 1 prospect in the organization, much to the delight of general manager Ron Hextall. (Photograph by Russ Cohen.)

10

RECENT FLYERS

Since 2005, the Flyers have had a number of strong squads that were true Stanley Cup contenders. During this period, they have been to two Eastern Conference Finals (2005 and 2008) and one Stanley Cup Final (2010). They have been close to a championship but have been unable to secure the franchise's third Stanley Cup.

There have been numerous highly talented players who have put on a Flyers jersey in recent years. There has been no shortage of skilled players who made the Flyers one of the top teams in the NHL for the last decade.

They include several who were drafted by the team, including Simon Gagne, Sean Couturier, Mike Richards, Jeff Carter, Steve Downie, Joni Pitkanen, Patrick Sharp, and James van Riemsdyk. Others, like Peter Forsberg, Chris Pronger, Jaromir Jagr, Jeremy Roenick, Derian Hatcher, Kimmo Timonen, Eric Desjardins, Sergei Bobrovsky, Scott Hartnell, Danny Briere, Mike Knuble, and Ville Leino, have arrived via a trade or free agency.

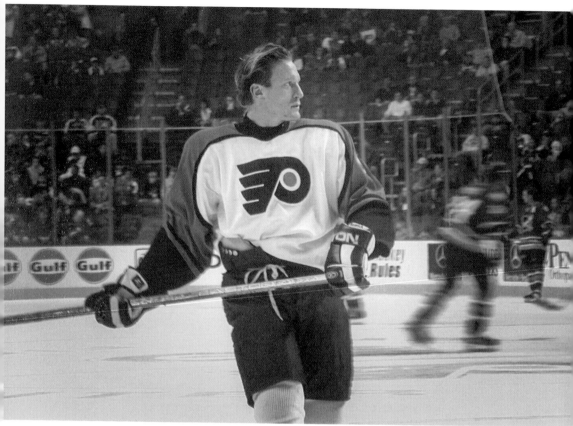

Jeremy Roenick, nicknamed "JR," was a very popular Flyer during his three seasons with the team. He was talented, rugged, unapologetic, and highly emotional—all qualities Philadelphia fans love. He will be most remembered by Flyers fans for his series-clinching overtime goal against the Toronto Maple Leafs in Game 6 of the second round of the 2004 playoffs. (Photograph by Joe del Tufo.)

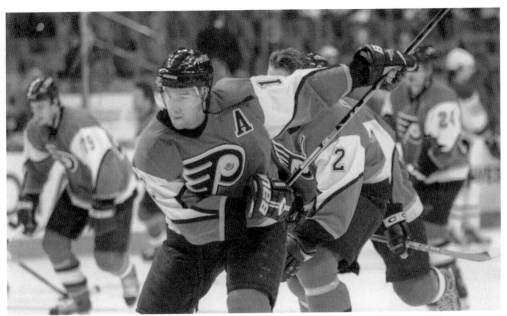

Winger Simon Gagne played nine strong seasons with the Flyers. They originally selected him with the 22nd overall pick in the 1998 NHL Entry Draft. He joined the team in 1999 and scored 20 goals and 48 points in an impressive rookie season. He went on to become the face of the team for several years, winning the Bobby Clarke Trophy as the Flyers' MVP on two occasions. (Photograph by Joe del Tufo.)

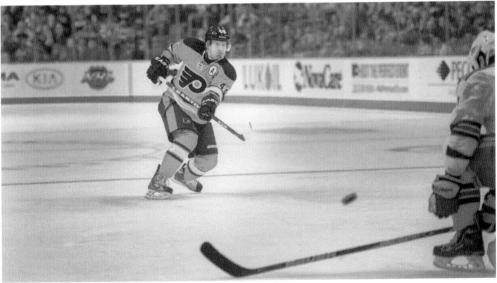

Defenseman Kimmo Timonen was a big addition to the Flyers in 2007 as he was acquired in a trade with the Nashville Predators. He would play seven seasons for the team, winning the Barry Ashbee Trophy as the Flyers' best defenseman five times. This Finnish blueliner was highly skilled and versatile and frequently logged many minutes every game for the Flyers. Here, he blasts a shot from the point. (Photograph by Joe del Tufo.)

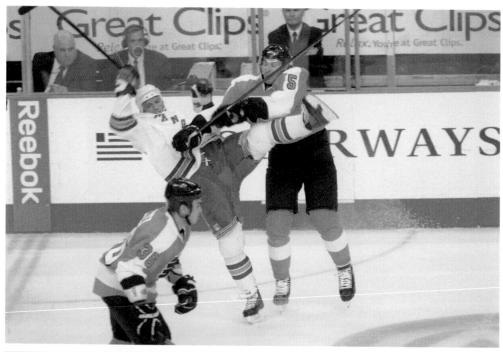

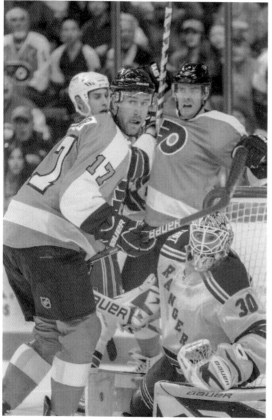

Sean Avery was one of the most hated players in the league for most of his career, which spanned from 2001 to 2012. He was particularly disliked in the City of Brotherly Love when he was acquired by the hated New York Rangers. In this picture, Flyers defenseman Braydon Coburn causes the crowd to roar loudly after laying Avery out with a big hit. (Photograph by Joe del Tufo.)

It has been said that a picture can say a thousand words. This hockey shot seems to say that former Philadelphia Flyers sniper Jeff Carter is getting into position, maybe on the power play, so he could try to deflect a puck past a top-notch goaltender, Henrik Lundqvist of the New York Rangers. Rangers defenseman Dan Girardi seems to have bodied Ville Leino off the puck, leaving Carter free in the crease. (Photograph by Joe del Tufo.)

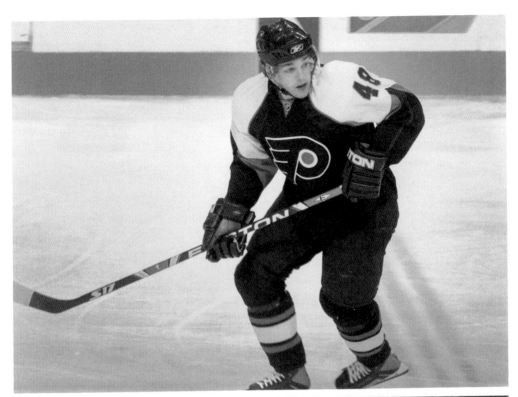

Forward Danny Briere was a big free agent signing for the Flyers in 2007. Briere was expected to instantly upgrade the team's offense. He did not disappoint, as he scored 31 goals and 72 points in 79 games in his first season in Philly. He was also vital to their playoff run to the Eastern Conference Final that season, as he scored 16 points in 17 games. (Photograph by Joe del Tufo.)

When the Flyers drafted Mike Richards with the 24th pick of the 2003 NHL Entry Draft, many saw the second coming of Bobby Clarke. He was a feisty, gritty, and strong two-way forward with a scoring touch. He went on to win two Bobby Clarke Trophies as the Flyers' MVP (2007–2008 and 2008–2009) and was named the Flyers' captain in 2008. (Photograph by Joe del Tufo.)

THE PHILADELPHIA FLYERS

Philadelphia sports fans are very passionate. What they love, they really love, and what they hate, they despise. Sidney Crosby came into the league in 2005 as a member of the rival Pittsburgh Penguins and quickly became the focus of the ire of Flyers' fans. Today, he is, in all likelihood, the most hated hockey player in Philly, and the fans let him know that whenever he visits. (Photograph by Mike del Tufo.)

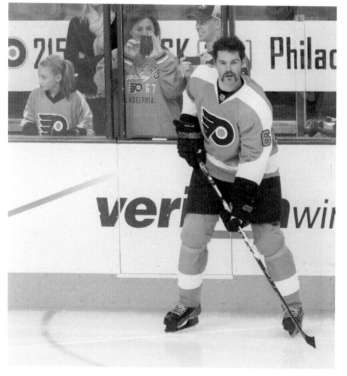

Jaromir Jagr only played for the Flyers for one season (2011–2012) but made quite an impression. He scored 19 goals and 54 points, but it was in the locker room where he had the most impact. His lighthearted personality, as well as his 20 years of experience in the NHL, was definitely missed when he left via free agency. Here is a rare picture of Jagr with a handlebar mustache. (Photograph by Drew King)

Winger Mike Knuble was the model of consistency during his stint with the Flyers. He scored 24 or more goals in four straight seasons with the club providing a strong presence in front of the opposition's net. Knuble was a good power forward that saw a lot of time on the team's top line, which had him playing with top talent such as Peter Forsberg and Simon Gagne. (Photograph by Drew King.)

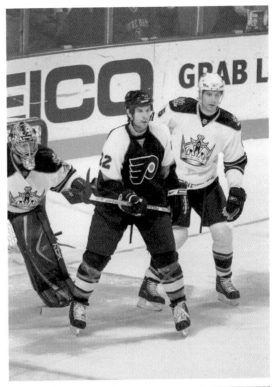

Gritty and feisty Ian Laperrière always seemed a great fit for the Flyers. He finally joined the team in 2009 for his final NHL season. He was a very popular player in Philly, both in the locker room as well as on the ice, but concussions forced him to retire after just one season with the team. He played in 1,083 NHL games, compiling 1,956 penalty minutes. (Photograph by Drew King.)

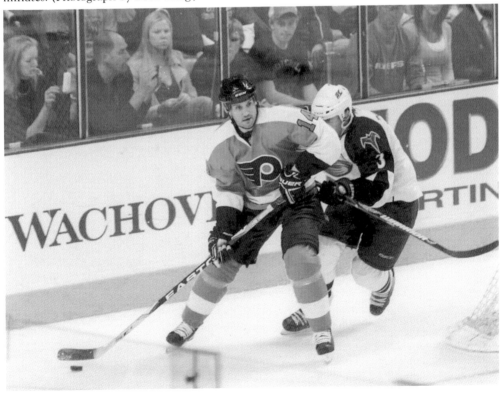

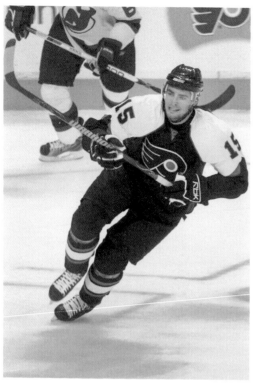

Joffrey Lupul only played two seasons with the Flyers from 2007 to 2009, but he scored one of the biggest playoff goals in the history of the team. In April 2008, he scored an overtime goal against the Washington Capitals in Game 7 of the first round. Lupul's time with the Flyers ended with being traded to the Anaheim Ducks in June 2009 for defenseman Chris Pronger. (Photograph by Joe del Tufo.)

Defensemen Danny Markov (left) and Kim Johnsson (right) were a big part of the Flyers playoff run in 2004 that saw them fall in Game 7 of the Eastern Conference Final to the Tampa Bay Lightning. Markov was a rugged and feisty presence in front of the net, and Johnsson brought strong offensive skills. Johnsson would twice win the Barry Ashbee Award as the team's top defenseman. (Photograph by Mike del Tufo.)

The Flyers acquired Chris Pronger in a trade in June 2009. Pronger had already established himself as a strong contender for the Hockey Hall of Fame prior to his arrival. His resume included a Hart Memorial Trophy as league MVP, a Norris Trophy as the league's best defenseman, and a Stanley Cup. He helped lead the Flyers to the Stanley Cup Final in his first season with the team. (Photograph by Joe del Tufo.)

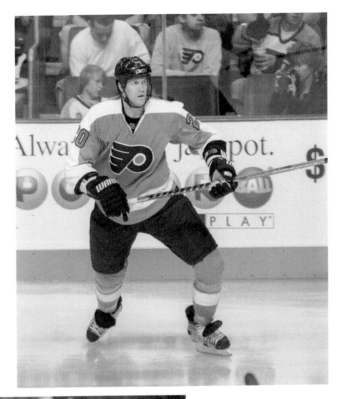

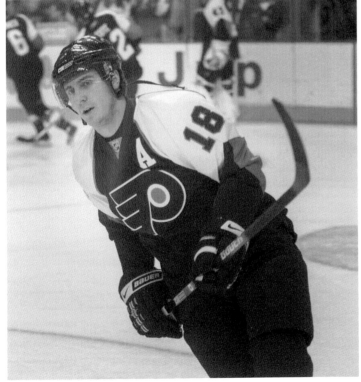

Mike Richards emerged as a star during the 2007–2008 season, his third season with the team and in the league. The Flyers named him an alternate captain in 2007, and he went on to lead the team in scoring that season, with 75 points on 28 goals and 47 assists. He also helped the team advance all the way to the Eastern Conference Final that season. (Photograph by Joe del Tufo.)

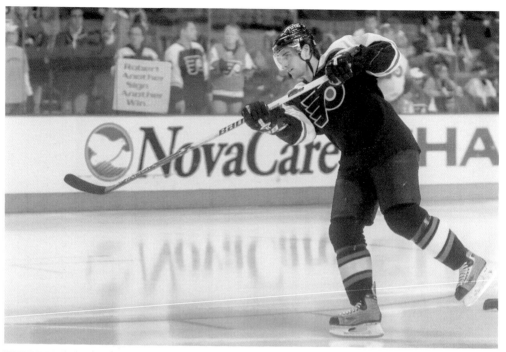

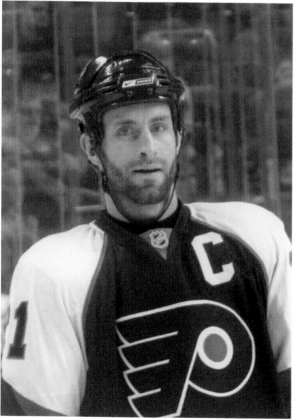

The Flyers selected Patrick Sharp with the 95th overall pick in the 2001 NHL Entry Draft. He came up through the Flyers system and was an important member of the Philadelphia Phantoms squad that claimed the Calder Cup Championship in 2005. He went on to play 66 games for the Flyers before they traded him to the Blackhawks in 2005, where he became a star. (Photograph by Joe del Tufo.)

Jason Smith was acquired in a trade in the summer of 2007. At the time, the Flyers captaincy was vacant, and the team decided to give the "C" to newcomer Smith. He was a rugged veteran who had been the captain of an Edmonton Oilers team that had just been to the Stanley Cup Final in 2006. (Photograph by Mike del Tufo.)

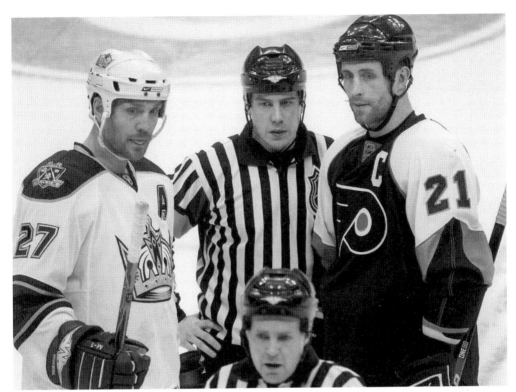

Jason Smith played only one season with the Flyers, but he was captain that season and led the team to the Eastern Conference Final. He ended up playing in the NHL for a total of five teams and 1,008 games. Here, he and Scott Thornton of the Los Angeles Kings discuss a call with the referee. (Photograph by Joe del Tufo.)

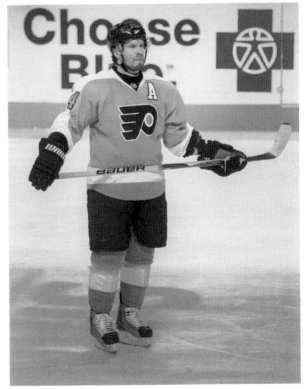

Defenseman Kimmo Timonen was not a highly touted prospect coming into the NHL; he was the 250th player selected in the 1993 NHL Entry Draft. However, he defied the odds and played over 20 years in the NHL, including seven with the Flyers from 2007 to 2014. He is third on the Flyers' all-time scoring list for defensemen. (Photograph by Joe del Tufo.)

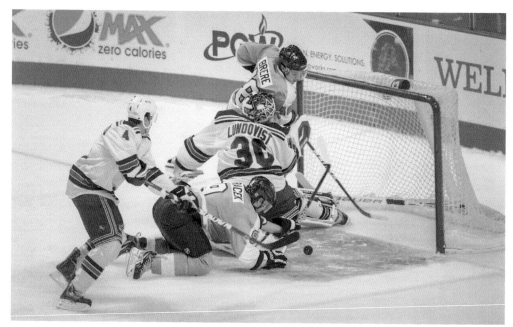

Sometimes it is good to be the king, and sometimes it is tough. On this night, New York Rangers goaltender Henrik Lundqvist had to deal with the high-flying, high-scoring Jake Voracek, who was in his kitchen, about to notch another goal to his statistics. (Photograph by Joe del Tufo.)

In what looks like a television timeout, Philadelphia Flyers captain Chris Pronger looks like his mind is somewhere else as backup goalie Brian Boucher attempts to communicate with the stoic star. Everybody needs a little rest, especially when he has logged as many minutes as Pronger did each game. (Photograph by Joe del Tufo.)

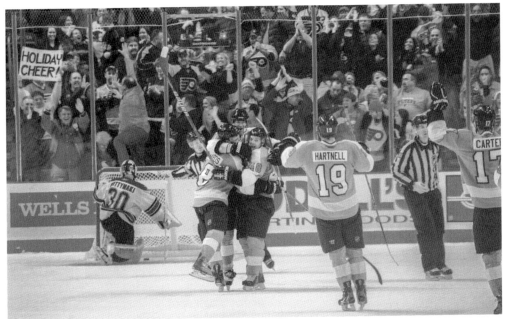

Philadelphia Flyers fans were looking for a little holiday cheer on the ice one night, and the team came through. Danny Briere and captain Mike Richards proceeded to be bear hugged by Chris Pronger. Scott Hartnell was late to the party, and the last player to celebrate was former Flyer and San Jose Sharks netminder Antero Niittymaki. (Photograph by Joe del Tufo.)

When captain Mike Richards faced the New York Rangers, he was always up for the challenge. The man who drew the assignment was former Flyers defenseman Steve Eminger. Considering Eminger lacked mobility, this was a matchup that Richards knew he could win, and one can see it in his eyes. (Photograph by Joe del Tufo.)

With Flyers captain Mike Richards on the doorstep, Bruins goalie Tim Thomas and defenseman Johnny Boychuk sprang into action. The Bruins rearguard tried to stop the puck, but it was up to Thomas, who at the time was the last line of defense for Boston. The Flyers did not score in that sequence. (Photograph by Joe del Tufo.)

Sergei Bobrovsky is a very athletic goalie. For the Flyers, he was a youngster, but what he seemed to lack in experience, he made up in other ways. This picture is a clear example; as he appears to be down and out on the ice, he still has the presence of mind to make the great leg save at the expense of one of his water bottles. (Photograph by Joe del Tufo.)

11

CURRENT FLYERS

The current Philadelphia Flyers squad is coming off of a tough season of 2014–2015 that saw them place 12th out of 16 teams in the Eastern Conference. It was their second time in three seasons missing the playoffs after missing it only once from 1995 to 2012.

Claude Giroux, their captain, and wingers Jakub Voracek and Wayne Simmonds lead the team. Giroux had 25 goals and 73 points in 2014–2015, while Voracek had 22 goals and 81 points, and Simmonds had 28 goals and 50 points. Mark Streit is their top defenseman, scoring 52 points last season. Steve Mason is their workhorse in the crease and is expected to play 50–55 games next season. He had an exceptional 2.25 goals against average and .928 save percentage in 51 games of action in 2014–2015.

Other prominent current Flyers include forwards Brayden Schenn, Sean Couturier, Matt Read, defensemen Luke Schenn, and Michael Del Zotto.

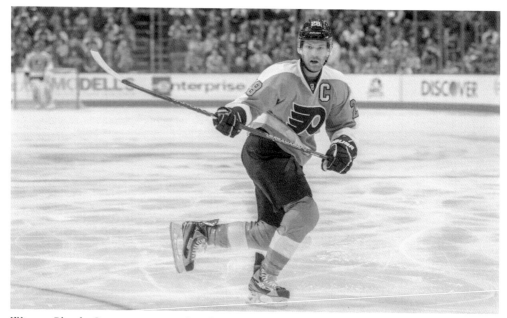

Winger Claude Giroux was named 19th captain of the Philadelphia Flyers in January 2013. He was the team's first-round draft pick in 2006 and has developed into one of the NHL's top players. He has already amassed quite a strong resume in his short career, having been nominated for NHL's Hart Memorial Trophy as the league MVP following the 2013–2014 season. (Photograph by Joe del Tufo.)

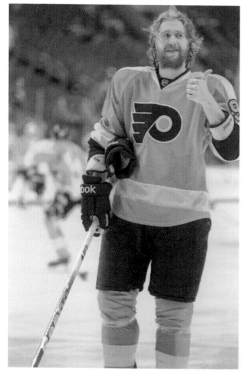

The Columbus Blue Jackets used the No. 7 overall pick in the 2007 NHL Draft to select winger Jakub Voracek. He played three unexceptional seasons there before being traded to the Flyers. His career has taken off since arriving in Philadelphia. He really blossomed during the 2014–2015 season, as he averaged a point per game and contended for the Ross Trophy as the league's leading scorer. (Photograph by Joe del Tufo.)

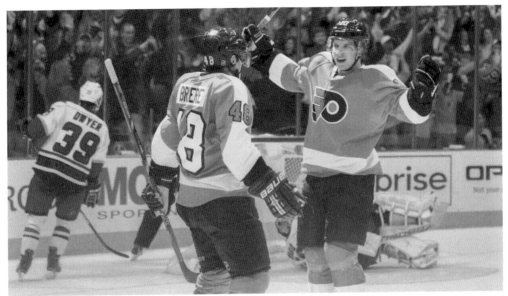

Forwards Danny Briere and Brayden Schenn celebrate a game-winning overtime goal against the Carolina Hurricanes back in February 2013. Schenn was the fifth overall pick in the 2009 NHL Entry Draft. The Flyers acquired him and Wayne Simmonds in 2011 in a blockbuster trade that saw their captain Mike Richards depart for the Los Angeles Kings. (Photograph by Drew King.)

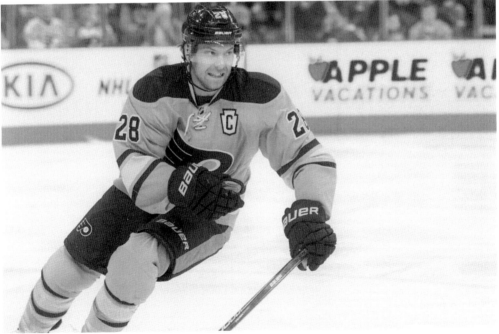

Claude Giroux became the Flyers' captain on January 15, 2013. He responded that season with 48 points in the lockout shortened season of 48 games. He has had four 25-goal seasons with the Flyers and has won the team MVP (the Bobby Clarke Trophy) three times. Here, Giroux has an intense look on his face as the action heats up. (Photograph by Joe del Tufo.)

THE PHILADELPHIA FLYERS

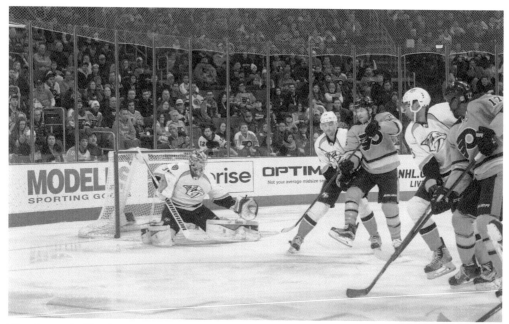

Flyer forwards Claude Giroux and Wayne Simmonds were quite an imposing duo for the Nashville Predators defensive pairing of Seth Jones and Mattias Ekholm to deal with in front of the net. Simmonds scored the first goal in this game and then scored in the shootout, as the Flyers prevailed 3-2 in the shootout. (Photograph by Joe del Tufo.)

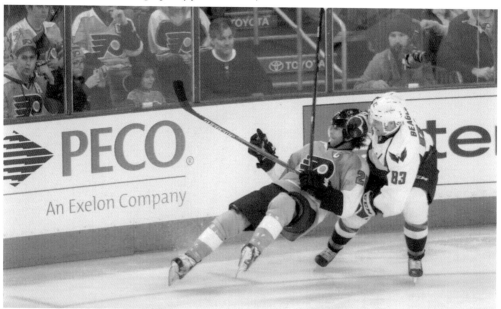

Flyers captain Claude Giroux gets taken down by Jay Beagle of the Washington Capitals. Giroux is a fast, aggressive, and elusive forward who presents a variety of problems for the opposition. He is difficult to contain, and his style is apt to draw quite a few penalties from opposing skaters. Giroux finished the 2014–2015 season with 73 points in 81 games. (Photograph by Joe del Tufo.)

CURRENT FLYERS

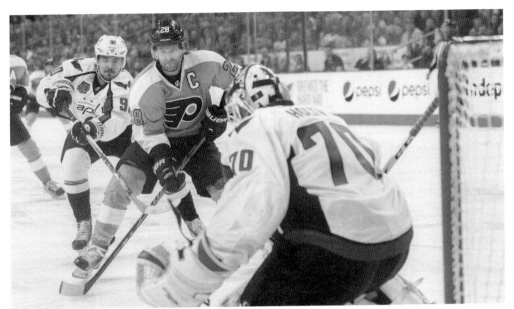

Flyers Claude Giroux closes in on a loose puck as Capitals goalie Braden Holtby attempts to cover it. Right behind Giroux is Caps winger Marcus Johansson, who is attempting to tie up his stick. Giroux had a strong game, as he recorded a goal and an assist and had five shots on the goal in this game, which the Flyers won 3-2. (Photograph by Joe del Tufo.)

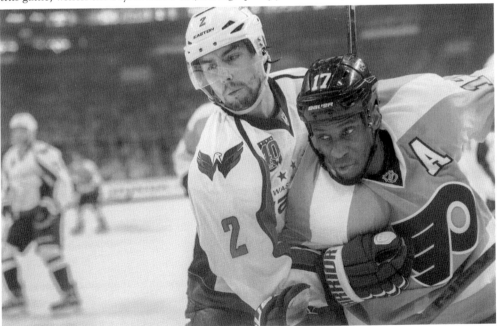

Flyers Wayne Simmonds, who is one of the top power forwards in the league, attempts to power by Capitals defenseman Matt Niskanen. Simmonds scored on the power play in this game and ended up being the Flyers' leading goal-scorer during the 2014–2015 season with 28 goals. He recorded 29 goals in the 2013–2014 season. (Photograph by Joe del Tufo.)

THE PHILADELPHIA FLYERS

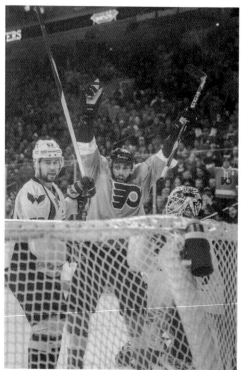

Flyers winger Pierre-Edouard Bellemare raises his arms to celebrate a goal by the orange and black as Capitals defenseman Mike Green looks on. Bellemare, a rookie during the 2014–2015 season, recorded six goals that season for the Flyers. He is a French player who the Flyers signed as a free agent in 2014. (Photograph by Joe del Tufo.)

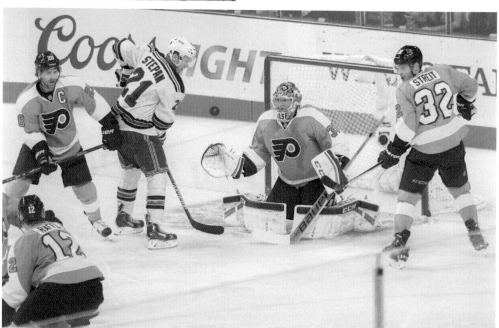

All of the players appear frozen with the puck in the air. Flyers goalie Steve Mason is in the ready position, and Rangers Derek Stepan looms dangerously above the crease. Mason does make the save. He ended the game with 34 saves and helped the Flyers skate to an important 4-2 victory over their hated rivals. (Photograph by Joe del Tufo.)

CURRENT FLYERS

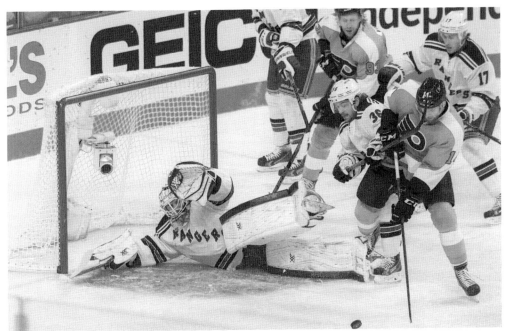

Flyers center Sean Couturier looks to have the advantage against Rangers goalie Henrik Lundqvist. Rangers forward Mats Zuccarello looks to negate that advantage as he checks and battles him around the crease. Couturier is unable to deposit the puck into the net, but he does record two assists in this Flyers' 4-2 win. (Photograph by Joe del Tufo.)

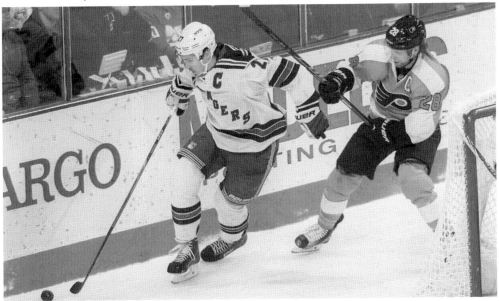

It is a battle of captains between Flyer Claude Giroux and Ranger Ryan McDonough. McDonough attempts to use his body to shield the puck from Giroux. Giroux, named the 19th captain of the Flyers in January 2013, succeeded defenseman Chris Pronger as captain. (Photograph by Joe del Tufo.)

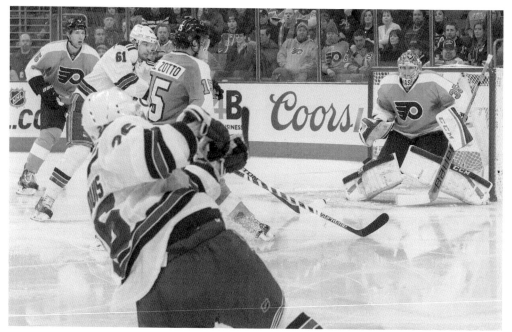

Rangers winger Marty St. Louis unleashes a shot at Flyers goalie Steve Mason while Rangers winger Rick Nash and Flyers defenseman Michael del Zotto vie for position in front of the net. Although the Flyers failed to qualify for the postseason in 2014–2015, Mason posted strong numbers for the team in net. He had a goals against average of 2.25 and a .928 save percentage, the best in recent Flyers' history. (Photograph by Joe del Tufo.)

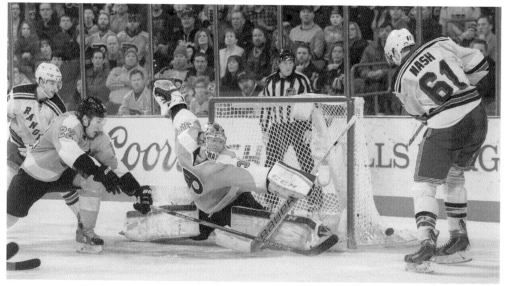

Rangers sniper Rick Nash misses a shot on Flyers goalie Steve Mason as defenseman Luke Schenn rushes to his aid. Ranked third in the NHL in goals with 42, Nash did not miss too many shots during the 2014–2015 season. That was his third season with 40 or more goals and his tenth season with 25-plus goals. (Photograph by Joe del Tufo.)

Flyers captain Claude Giroux sports the rugged playoff warrior look, which is fairly common in the NHL during the postseason. He is working on a playoff beard and is missing a tooth. Giroux has been a very effective player in the playoffs, scoring 23 goals and 61 points in 57 playoff games for the Flyers. (Photograph by Joe del Tufo.)

Hockey is the only one of the four major sports in North America that has players coming on and leaving play as the action is happening. Here, the Flyers execute a shift change. Ideally, this is done when the puck is deep in enemy territory so there is little chance of them being caught with an odd-man rush going against them. (Photograph by Joe del Tufo.)

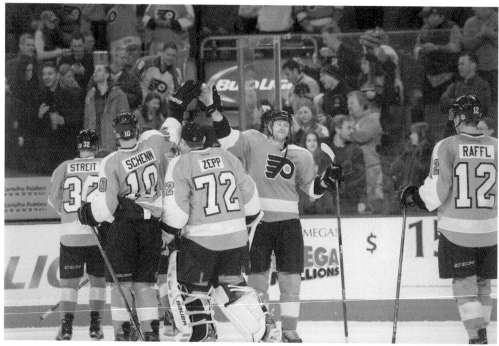

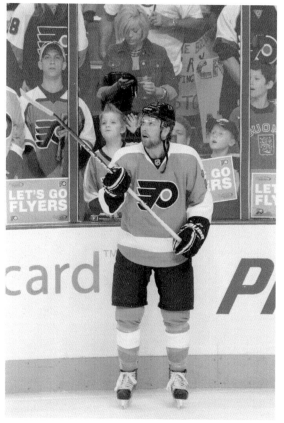

Here, Flyers winger Jakub Voracek is high-fiving teammates. Voracek ended the 2014–2015 with 81 points on 22 goals and 59 assists, which placed him in fourth on the NHL scoring list for that season. He was originally acquired in the trade that sent Jeff Carter to the Columbus Blue Jackets in 2011. Many saw potential, but few expected him to blossom into one of the top forwards in the league. (Photograph by Joe del Tufo.)

Flyers captain Claude Giroux, pictured during a pregame skate with fans in background, developed from a player with potential to a superstar over the course of several years. He scored 27 points during 2008–2009. He followed that with 47 points the following season and an impressive 76 points in 2010–2011. His best season currently is the 2011–2012 one, where he compiled 93 points on 28 goals and 65 assists. (Photograph by Joe del Tufo.)

CURRENT FLYERS

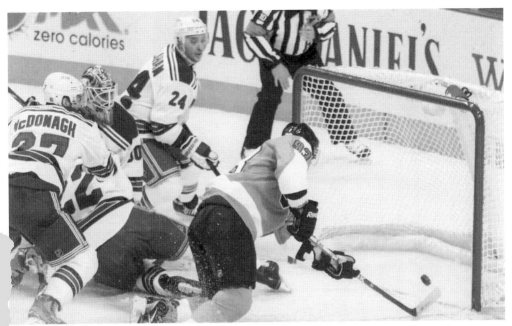

Games between the Flyers and New York Rangers are usually physical and full of exciting plays. Here, there is a mad scramble in the goal mouth of the Rangers' net as the loose puck dribbles out to a diving Jakub Voracek with nothing but a wide open net in front of him. It is quite a rare occasion to see Ranger netminder Henrik Lundqvist so out of position. (Photograph by Drew King.)

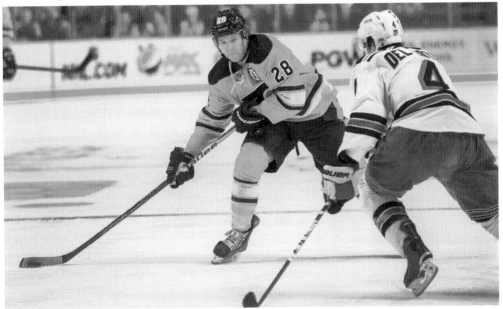

Flyers center Claude Giroux roars into the offensive zone with the puck as Michael Del Zotto of the New York Rangers defends against him. Del Zotto joined the Flyers as a free agent in 2014 and become teammates with Giroux. The Rangers selected Del Zotto with the 20th overall pick in the 2008 NHL Entry Draft. (Photograph by Joe del Tufo.)

THE PHILADELPHIA FLYERS

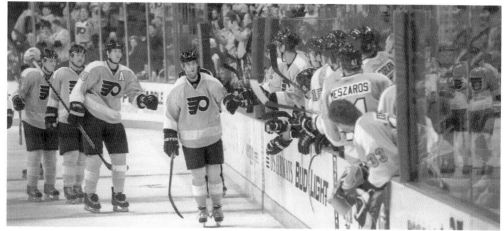

Following a Flyer goal, winger Ville Leino heads to the bench to fist bump his teammates. Future Hall of Famer defenseman Chris Pronger and Scott Hartnell follow him. At the end of the bench, backup goalie Brian Boucher (No. 33) awaits the procession as he reaches over in anticipation of that good fist-bump karma. (Photograph by Joe del Tufo.)

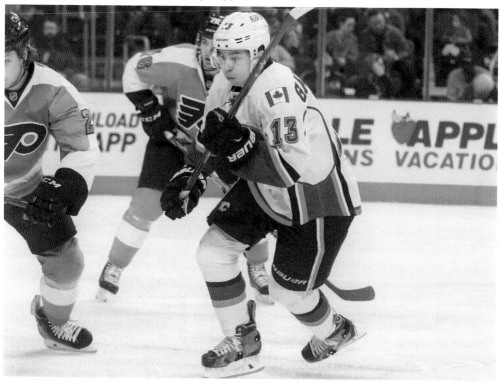

Johnny Gaudreau, nicknamed "Johnny Hockey," returned to the Wells Fargo Center once again. The South Jersey kid competed in the Frozen Four a few months earlier for Boston College, and then he went on a tear in the NHL for the Calgary Flames. To the surprise of nobody in South Jersey, where he grew up, he put up numbers good enough to become a Calder Memorial Trophy finalist. (Photograph by Amy Irvin.)

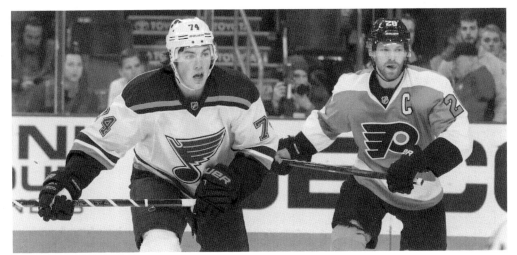

During the 2014–2015 season, Philadelphia Flyers captain Claude Giroux found out firsthand how hard it is to keep up with then St. Louis Blues and US Olympic speedster T.J. Oshie. With Ken Hitchcock behind the bench for the Blues, it was an interesting late-season game. (Photograph by Amy Irvin.)

Mark Streit was a solid trade when new general manager Ron Hextall acquired the rights to negotiate with the talented blueliner at the 2014 NHL Entry Draft. He is a solid offensive contributor, and he can strip the puck away from some of the best forwards, like Tyler Seguin of the Dallas Stars. In his second season with the Flyers, he had 52 points, which ranked in the top 10 in his position. (Photograph by Amy Irvin.)

DISCOVER THOUSANDS OF LOCAL HISTORY BOOKS
FEATURING MILLIONS OF VINTAGE IMAGES

Arcadia Publishing, the leading local history publisher in the United States, is committed to making history accessible and meaningful through publishing books that celebrate and preserve the heritage of America's people and places.

Find more books like this at
www.arcadiapublishing.com

Search for your hometown history, your old stomping grounds, and even your favorite sports team.